THE DANCE OF 1000 FACES

David Shillinglaw

"Are we to paint what's on the face, what's inside the face, or what's behind it?"

- Pablo Picasso

This edition published 2015 by Unicorn Press Ltd
ISBN 978-19100-65570
Unicorn Press Ltd, 66 Charlotte Street, London, W1T 4QE
Originally published by Nowhere North
© 2012 David Shillinglaw

Edited by David Shillinglaw and Joanna Dudderidge
This edition project managed by Ellen Parnavelas

Unicorn Press

FOREWORD by Jaybo Monk

"At any moment, you have a choice, that either leads you closer to your spirit or further away from it."
It is difficult to find a vivid term to describe the work of David Shillinglaw. It all began with a pencil, I guess. David is always asking himself, always answering himself, permanently punctuating his life by bits and pieces on paper, walls or canvas. David is a mind adventurer, where the left half of the brain explores the right one. Unanswered, impulsive, instinctive and restless - David doesn't paint or draw, he creates time. He is a poet at the first place and as the true poet is a traveller in all forms of transportation, David dwells in his own lovely and terrible wilderness… A very intimate place harshly and beautifully colored with signs of conversations, broken thoughts and visual notes. Each period of David´s work tends to correspond towards the hidden riddims of his life. It flows between anxiety, tenderness, fear, rage, love and is always escorted by a stoic humorous calm. All poetry sounds the same when spoken through the mouth, a place where too many words have been tortured. Shillinglaw suspends our attention above the written word and lets us rediscover the visuality of a letter, the first absolute work of metaphor, the first movement of common abstraction. The words seem true when written.

Anything can serve the purpose of defining his daily experiences. Not the material, but the journey defines his work best. For a quick transfer of his everyday input to a medium, David prefers to use drawings. The intuitive drawing style and realistic writing of words give the drawing a mundane acceptability. Upon further examinations or discoveries of his working method, the image becomes ridiculous. The juxtaposition of such words and drawings creates a sense of disbelief, but since Shillinglaw puts his own personality in his work, he simultaneously incorporates fantasy, humour and nostalgia, which combine to drive the idea home, not through the seemingly childlike drawing style, but through logical discrepancies. Caught up in every second of his work he uses this direct feedback to entertain himself as well as the viewer and creates perfectly timed conversations. He describes a character, a face, a dog, a child, a victim of circumstance, a situation, with his mild approach he encourages trust and suspends disbelief in the viewer. He stereotypes himself. Shillinglaw uses words as close ups and visual pins to deceive the eyes and to misconstruct expectations. He incorporates sometimes well timed graphic shapes in his narration, by splitting them into louder and more quiet visual silences. Through his new body of work, "The Dance of 1000 Faces", David traces his obsession with the human failure of interpretation. Not so far from the African craft, he carves the map of faces with wrinkles, scars, eyes and hidden thoughts. He takes humanity by the wounded point: the word. He uses it and plays with it, rehearsing his own stereotypes, his pictorial reflections for "face" or "body" over and over again.

Evident in all his work is that David Shillinglaw is not afraid to humanise his art. He incorporates the perceptual concern of his journey as a man with his own sense of humour. The result is a powerful and fresh interpretation of everyday reality. His art has the appeal of Pop but a friendly, subtle, self effacing Pop that presents the ordinary and delights the viewer when he shows that you have your best conversation with yourself.

REASONS TO BE CHEERFUL

by Marnie Serpell
Managing Director Agnès b. U.K. ltd.

I first heard of David when I received a letter in 2006, complimenting me on my store in Hampstead and then proposing the installation of an art exhibition there. This show was called Reasons to be Cheerful. When I saw David's' work I was excited. The energy of each piece, the structure and thought process clearly visible. Some works on found objects , some on canvas , all with their own story. Naïve yet intricate, scrambled words but a clear dialogue, vivid colour or line drawing each piece complex but simple. It really made me smile. It still does.

David is an outstanding person. The artwork he creates express his interest in life, culture, the environment and the human condition. He never stops observing and is unswerving in his desire to document daily life both inside and outside his self. We went on to host a second exhibition, Dreaming of Babylon and supported the launch of his first book, Colourful Condition.

David brings colour into peoples' lives both with his artworks and his self. He is a passionate, enthusiastic observer of life with a commitment to documenting the contradictions in life we all face daily.

I was thrilled to be invited to talk about David for this book and am even more thrilled to be able to call him my friend.

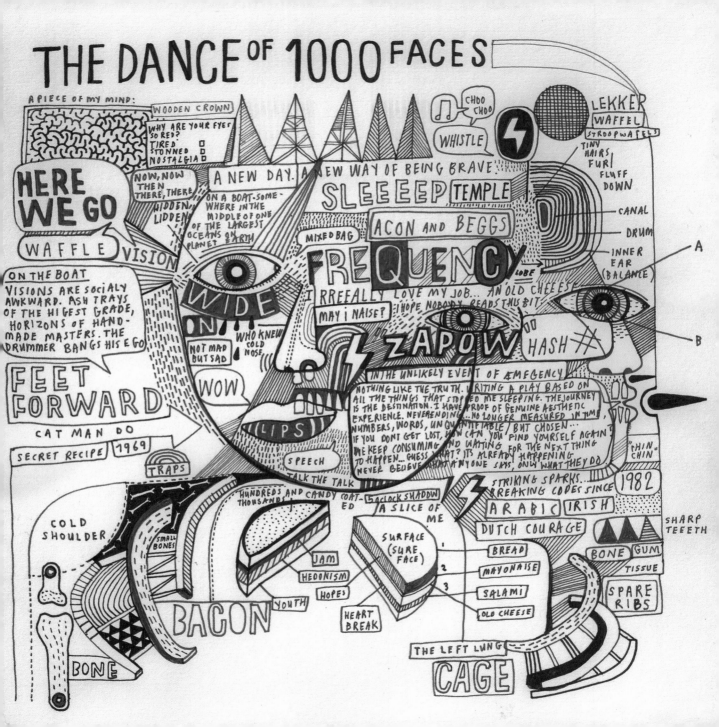

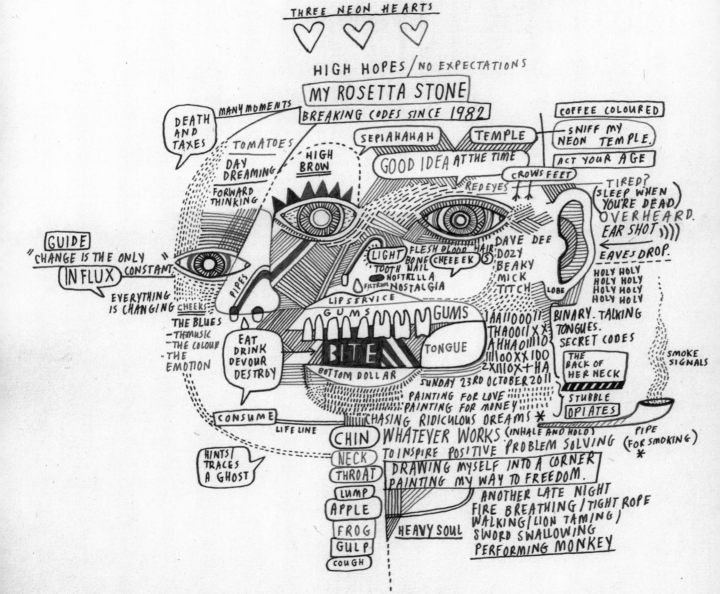

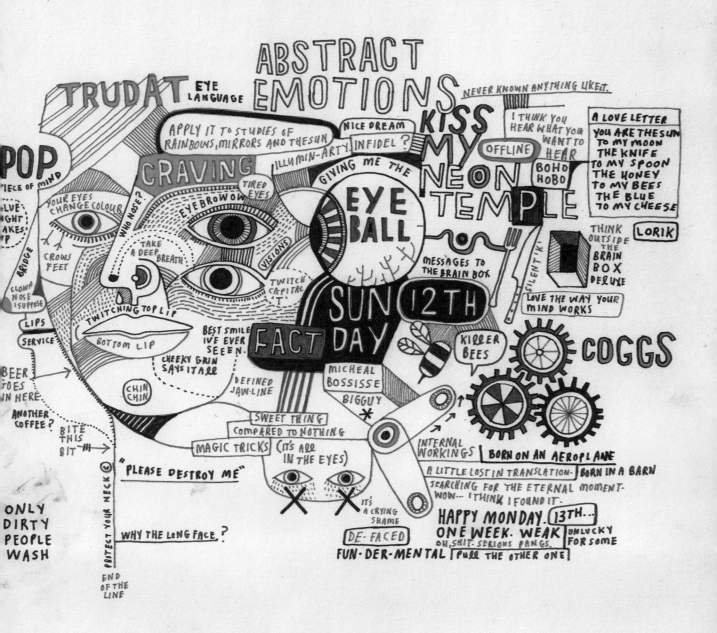

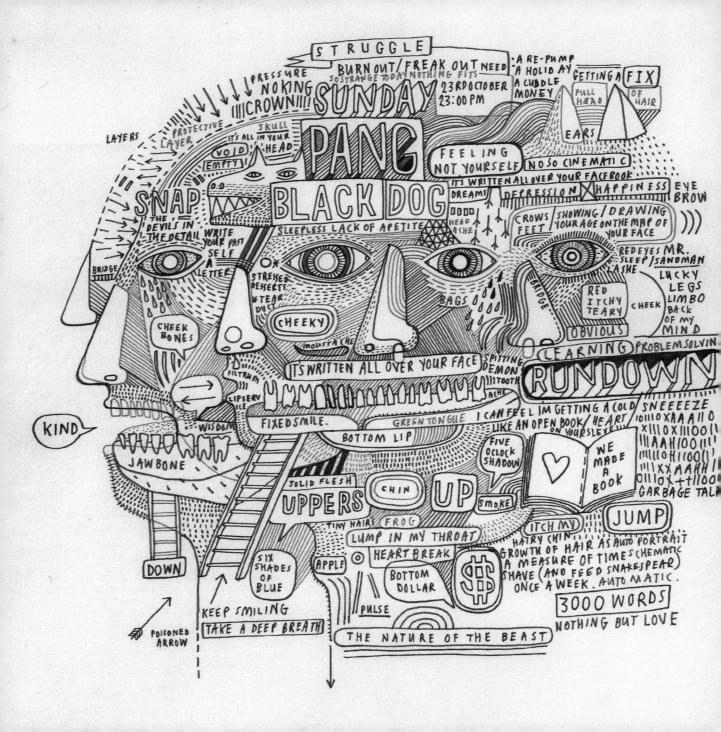

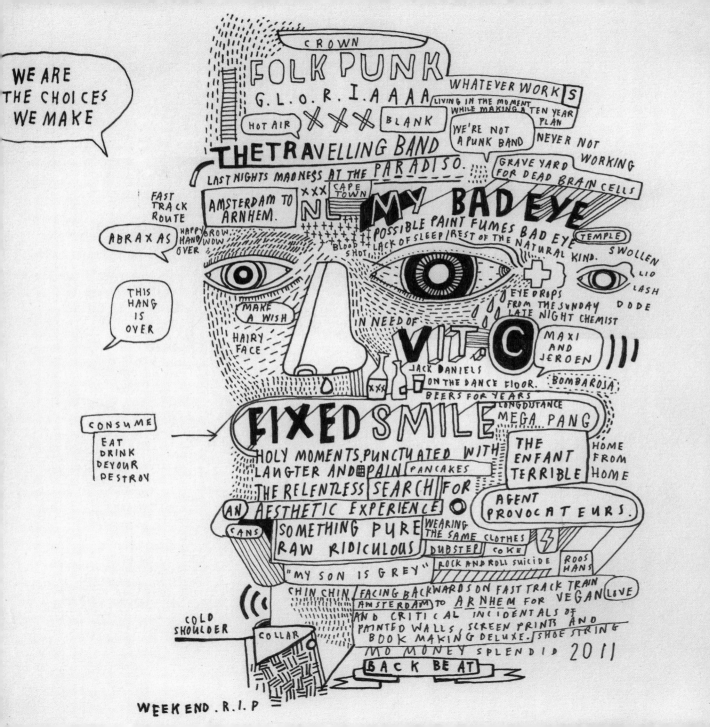

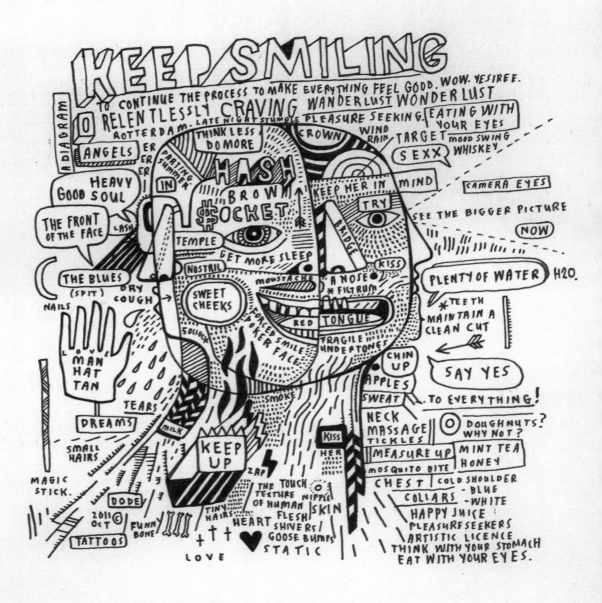

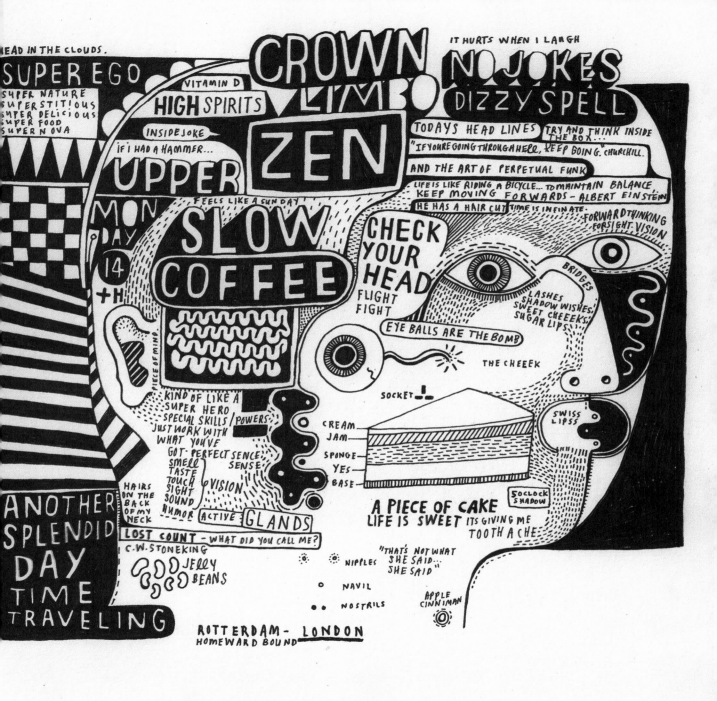

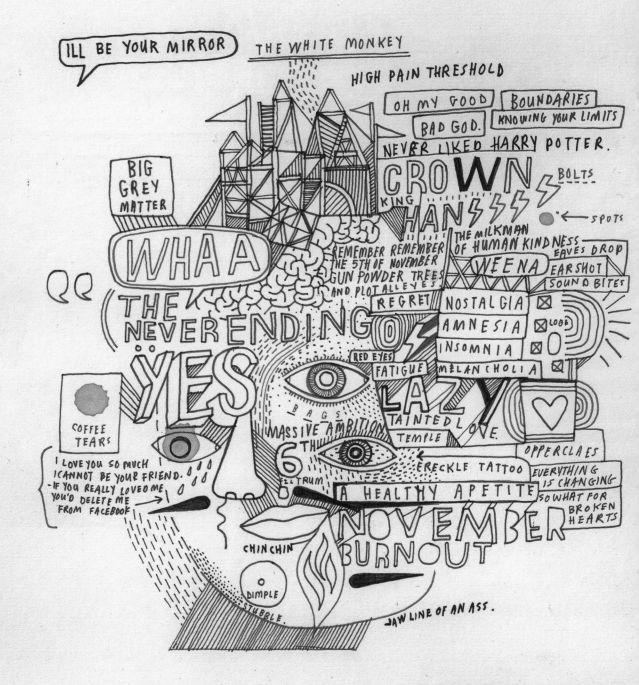

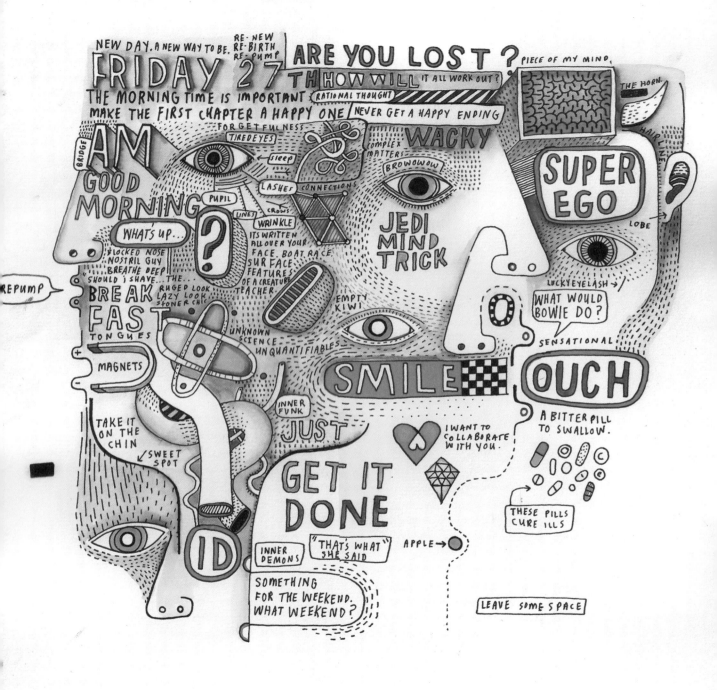

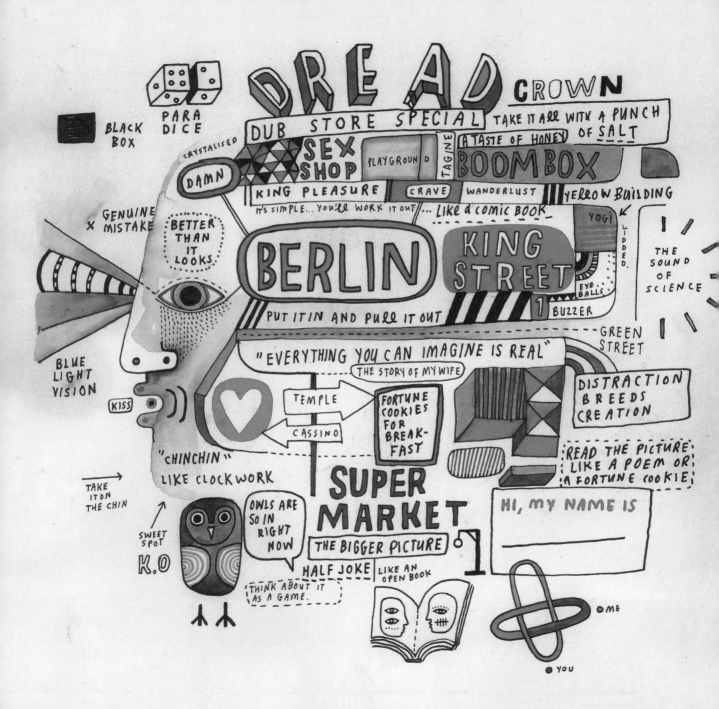

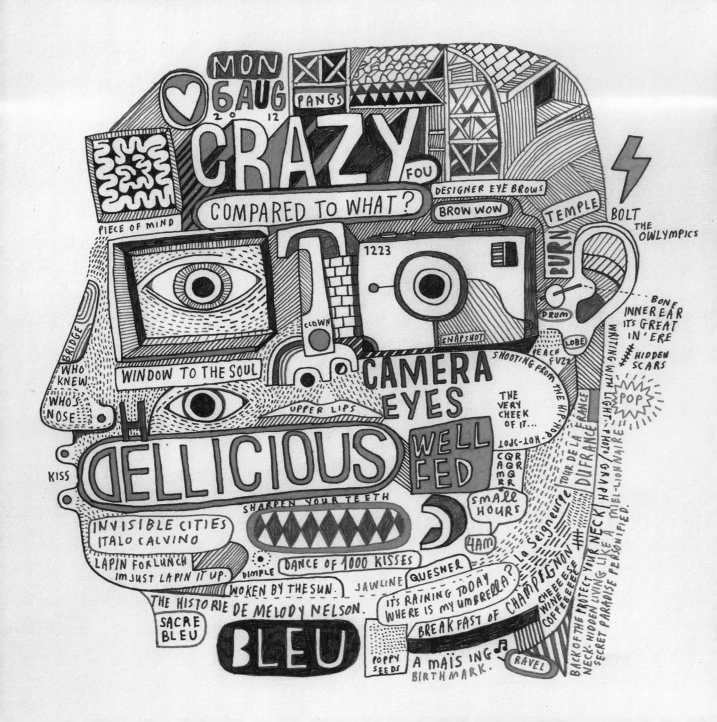

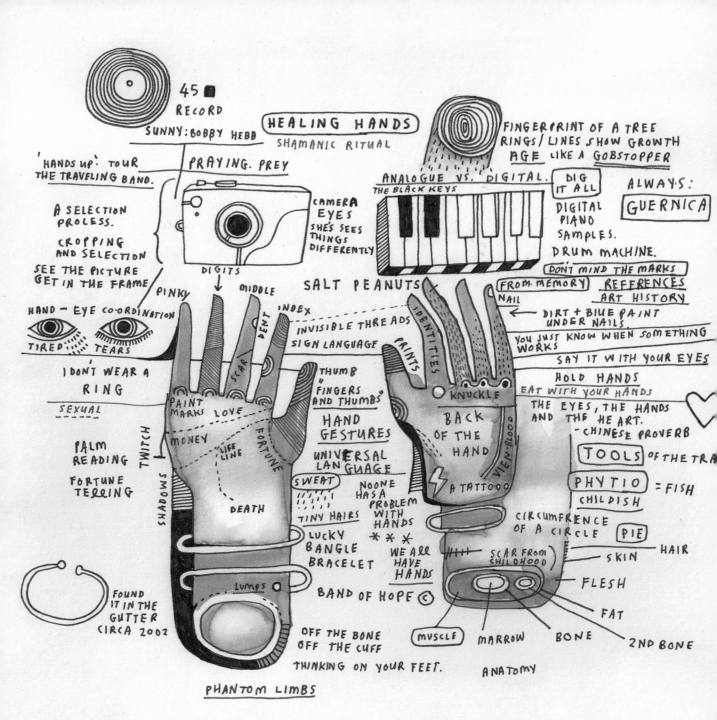

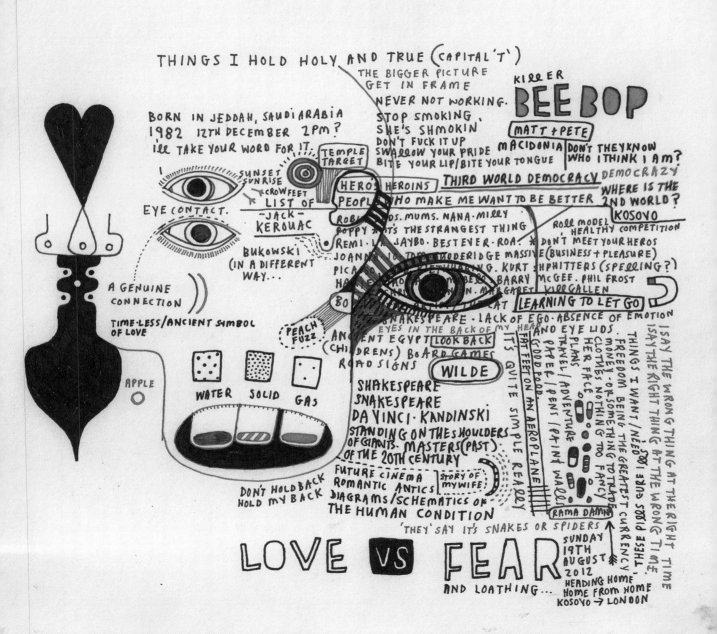

ICARUS

... LIKE, LET'S WORSHIP THE SUN

100 YEARS OF SOLITUDE
GREEK GODS BLUSH AND THE UNIVERSE SMILES...

ALL OUR CELLS ARE IN AGREEMENT.
DEVIL'S CLAW LANGUAGE
KAPOW UNIVERSAL OF 'WOW'

THE SKY IS CRYSTAL BLUE. YOU COULD DIVE RIGHT INTO IT, LIKE DEEP SEA ICARUS

NOW

MY GIRL THE 'G' WORD

ROOSTER CROW

MAPPING FUTURE CINEMA
BREAD AND CHOCOLATE

... LIKE PICASS UM, YEAH?

I SEE YOU

I'LL BE YOUR MIRROR

ANOTHER COFFEEEE

SORRY FOR LATING

HIGH PROFILE WORLD FAMOUS IN KOSOVO

I LOVE A GIRL WITH BALLS

FETA
CRAZY CHEEEESE

IT'S ALL IN THE EYES

TUESDAY 14TH AUGUST

PIECE PEACE PARK

WE'RE ON THE SAME PAGE

YESPLEASE

A NOSE FOR THINGS

WAITING FOR THE KEY

ALBANIAN ANATOMY

SAY IT WITHOUT WORDS

KISS

CLOSER

HONEST

MIX SALAD WITH EVERY THINK

BLAH

TRUTH. CAPITAL 'T'

DON'T HOLD BACK...

OMELET WITH EGGS

FIRST OF A MILLION KISSES

POWER CUTS

DRAWING BY CANDLE LIGHT

SORE THROAT

I GUESS THIS IS THE REAL DEAL

YOU'RE THE BEST- DEAL WITH IT

IT'S THE SAME IN EVERY LANGUAGE

SABRI FLORIST KELLY R.D.

DIP IT IN YOUR COFFEE

BLACK AND WHITE BEFORE I MET YOU

TASTES BETTER WITH YOU, BABY.

I FEEL LIKE THE MUSIC

HUNGRY EYES

POP

WEDNESDAY 15 IMPERFECT

CAMERA EYES

FEEL IT HERE

1 EURO

NOT SHOWERING IS THE NEW SHOWERING

LUMP AT THE BASE OF MINE SPINE... TRY TO TRY NO TO WORRY. OK DOCTOR.

HEEL / HEAL
SOLE / SOUL

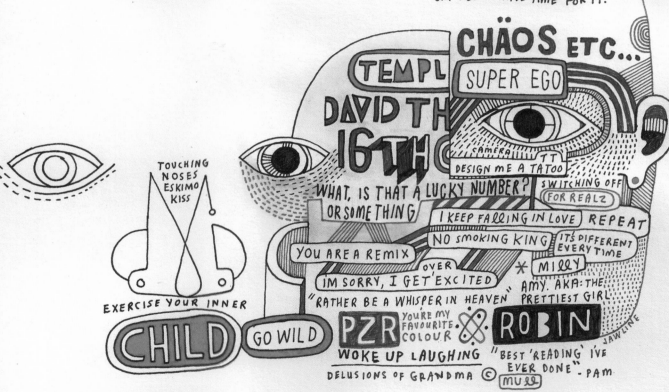

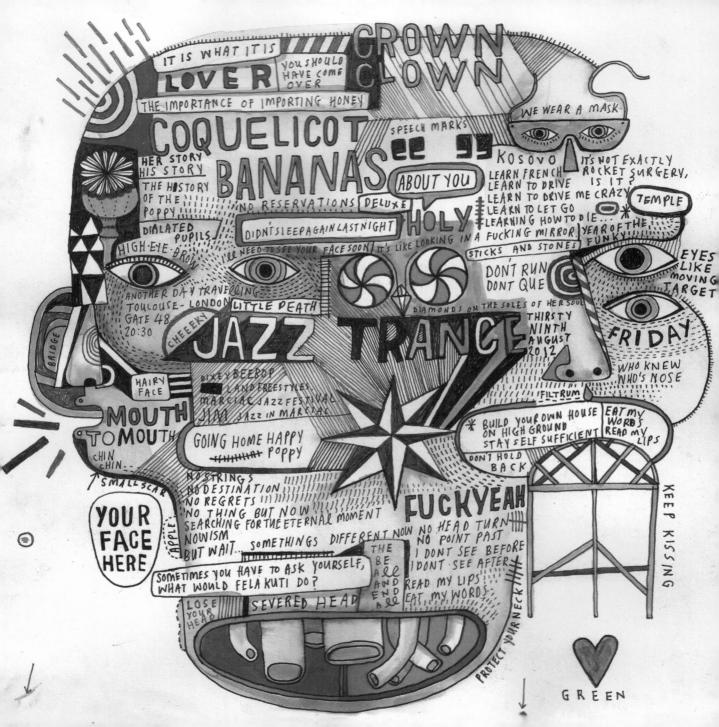

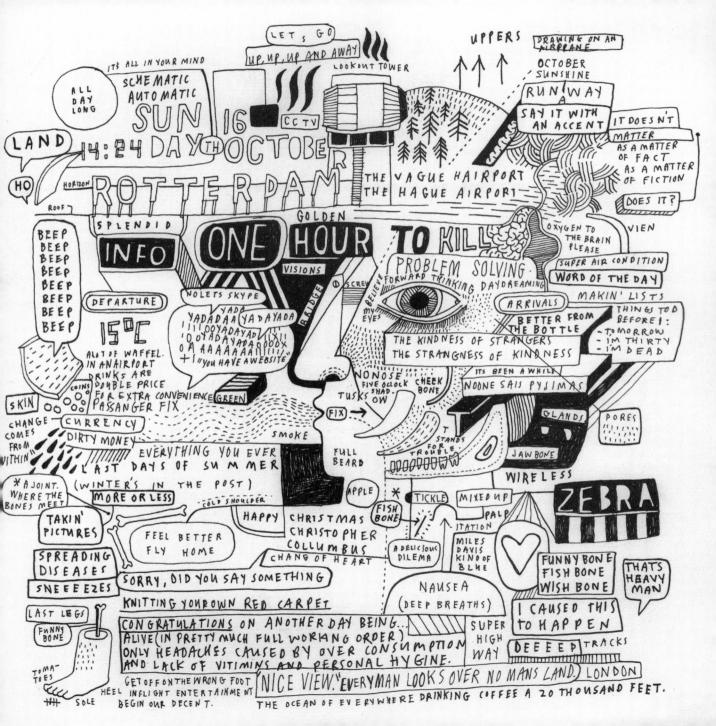

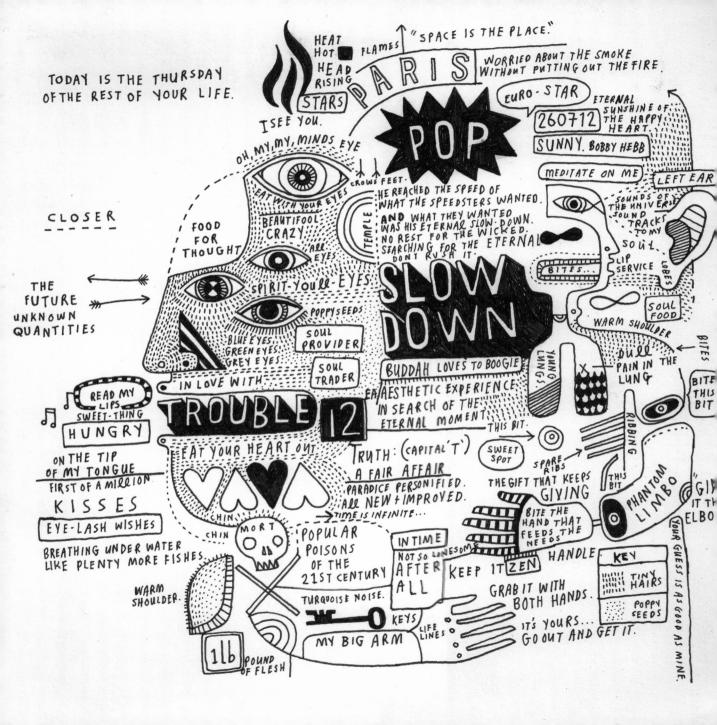

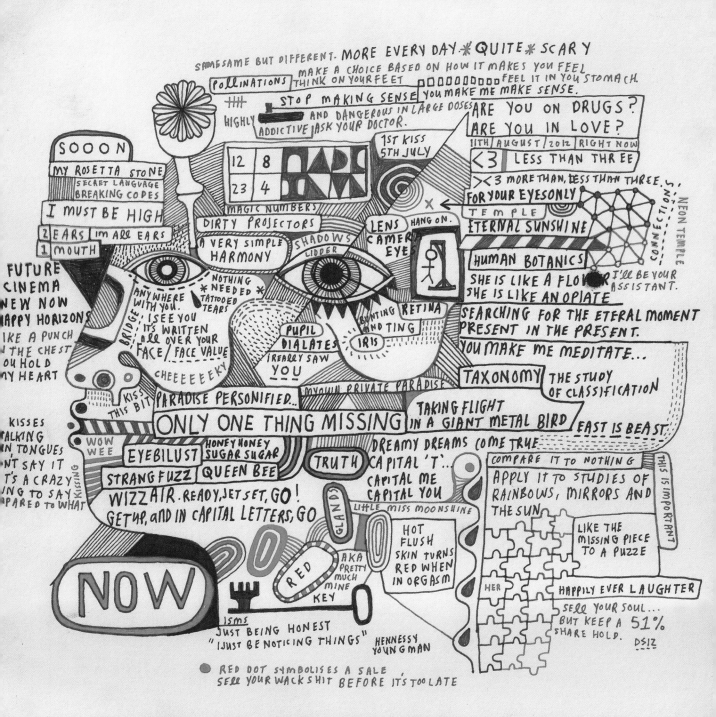

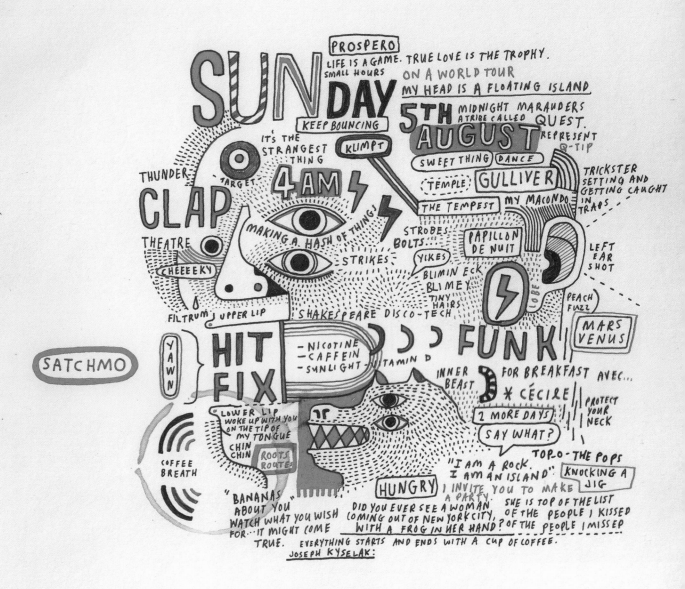

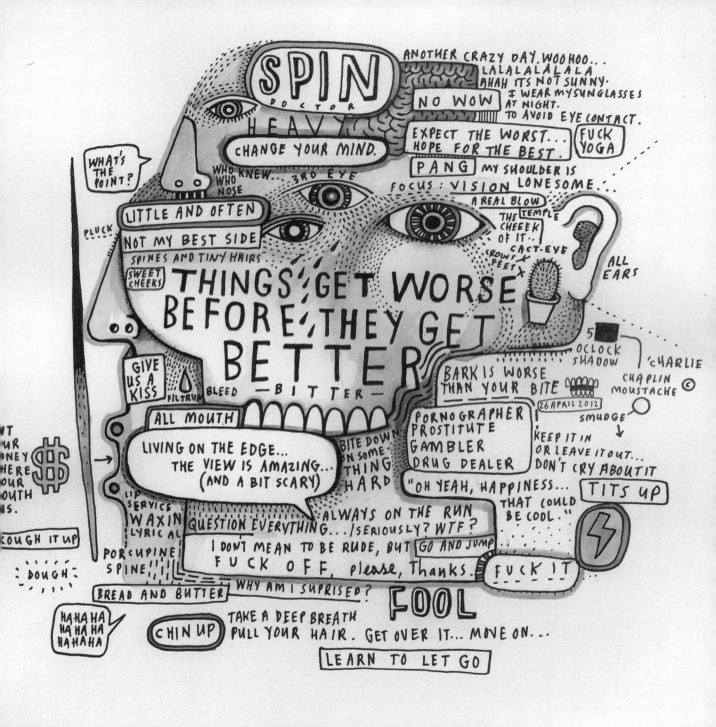

GAMBIA

NICE TO BE NICE: Painting in The Devil's Playground.

Landing at Banjul airport, the first thing that hits you is the thick heat. Like a hot slap in the face, from that point the heat follows you and becomes both a beast of burden and a new best friend. The sun is larger and hotter at the equator, easing off at sunset only to be replaced by a world of flesh-eating insects. The Gambia is known as 'The Smiling Coast of Africa', the name comes from the apparent smiling shape of the river Gambia that grins it's way through Senegal from the Atlantic Ocean.

We had flown to Gambia to paint. This was all I knew. My travelling companions had made the trip previously, and although they kept most of the details a mystery, I felt sure they were leading me in the right direction. Our destination was a lodge in the Makasutu area, also known as 'The Devil's Playground', a pocket of paradise, bang smack in the middle of jungle, resting on the banks of salt water rivers, tangled up in a knot of ever expanding mangroves, home to crocodiles, rare birds and an army of baboons.

My company included a mix of artists, all there for the same reason; to paint, and to explore. The aim of the trip was to share what we do with the local villages, using our art to bring to life otherwise blank or broken walls. An exchange of sorts, a collaboration with the environment, a shift of context, a refreshing slant on the world of 'Street Art', and ultimately an opportunity for both parties to discover something.

Art, especially painting, speaks a universal language, and has the power and potential to cross cultural boundaries and speak for itself; a silent statement, larger than life, free from advertising or pressures of commercial obligation. A large, black and white painting of a crocodile transforms a falling down wall into a focal point, often becoming a meeting point and talking point for all who pass it by. The painting itself becomes a social event and social sculpture, a catalyst for creative fun to be had. Children and adults observe, and look on with pride, with looks that say; 'that's our wall, that's our painting, this is our village'. In this way painting becomes the driving force, escaping the history and dogma of graffiti and high art, with no regard for money or publicity. With few words to communicate, facial expressions and smiles become currency, popularity and success is measured in how many children are assisting you, and payment comes in the purest form of mangos, roasted cashew nuts and the promise of a cold bottle of Jul Brew beer.

There is an unknown quantity to this project, a mystery of exactly how far the work reaches, added to by the lack of online publicity and documentation. The artworks shift between the main focus and somewhere in the background, hidden by bushes and passing cattle. The artworks remain unlabelled, untitled, and never for sale. At the root of the project I saw the reflection of the artwork in the bright eyes of children who are captivated by the very action of a brush or spray can on a wall, instinctively finding a pencil and piece of paper to copy and in turn take part.

I am still getting my head around the idea of white European street artist painting in remote African villages. It is easy to over-think this, and be over-critical of the reasons, methods and repercussions of such a cultural exchange. I am confident that from whatever side of the fence you stand, the result and effect is still the same: people love a big painting on their wall.

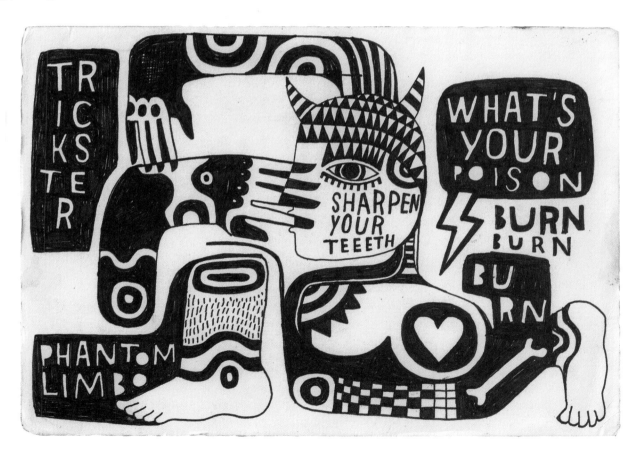

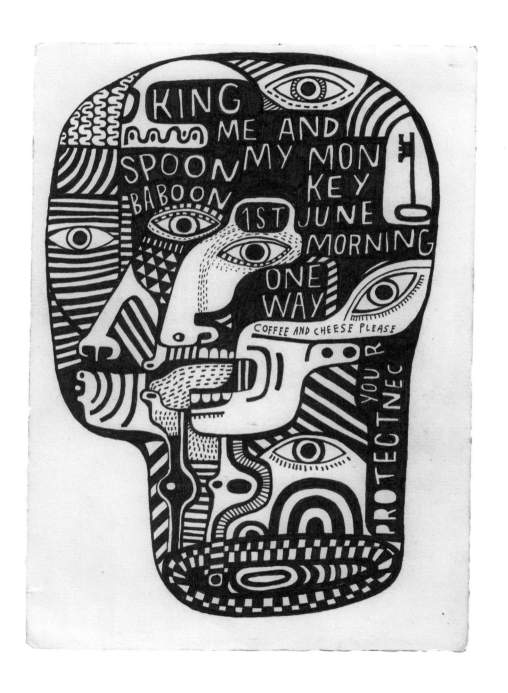

28

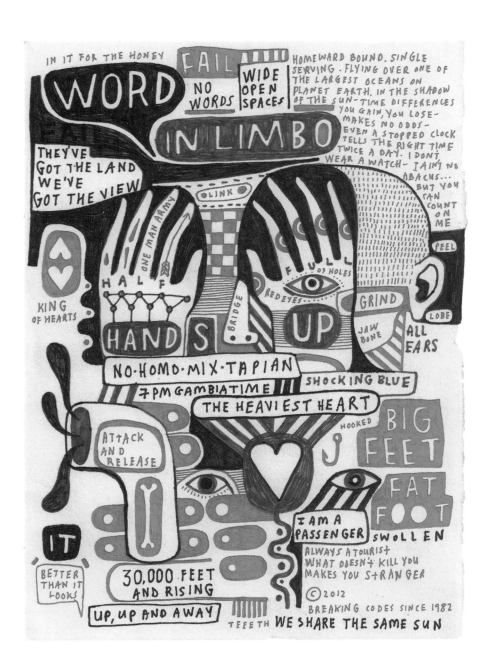

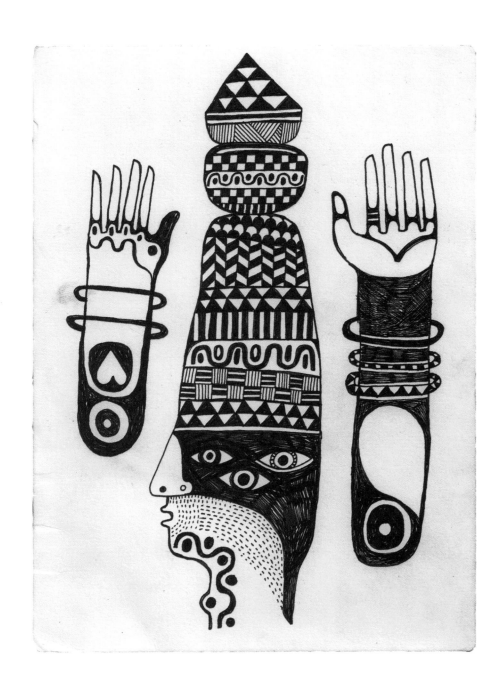

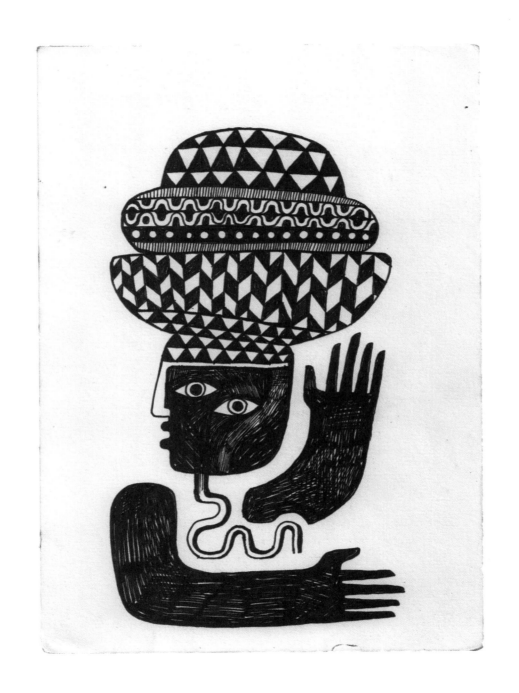

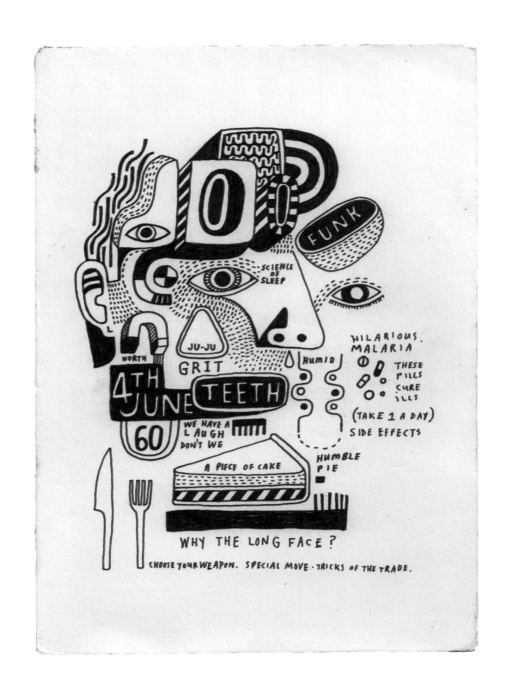

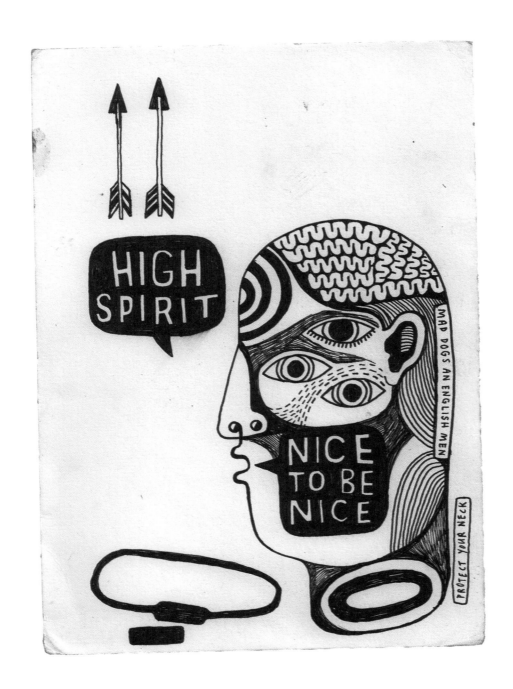

33

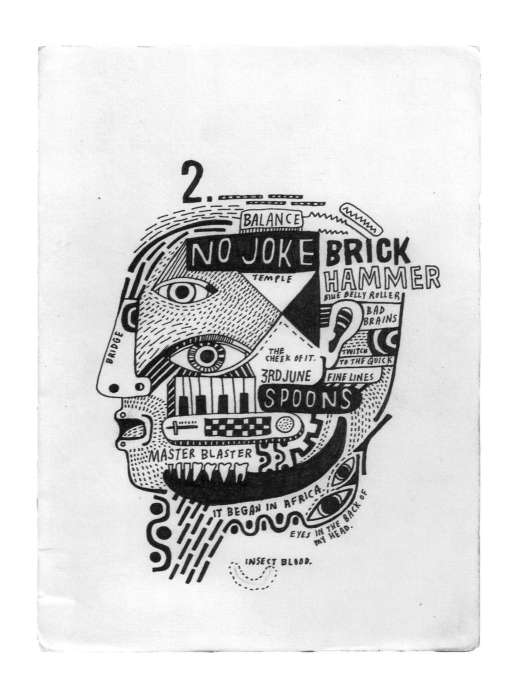

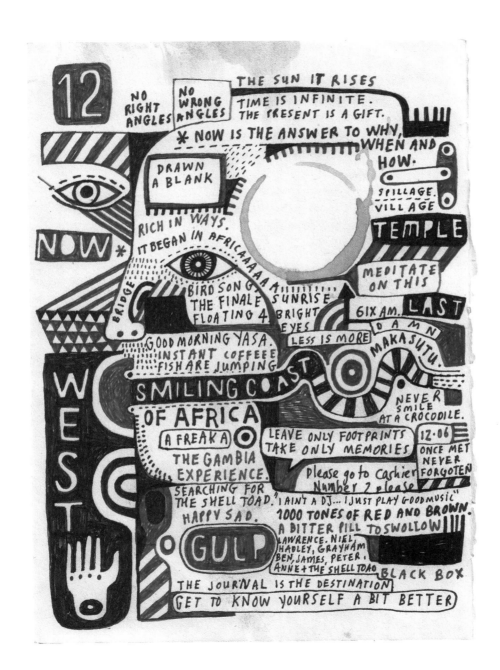

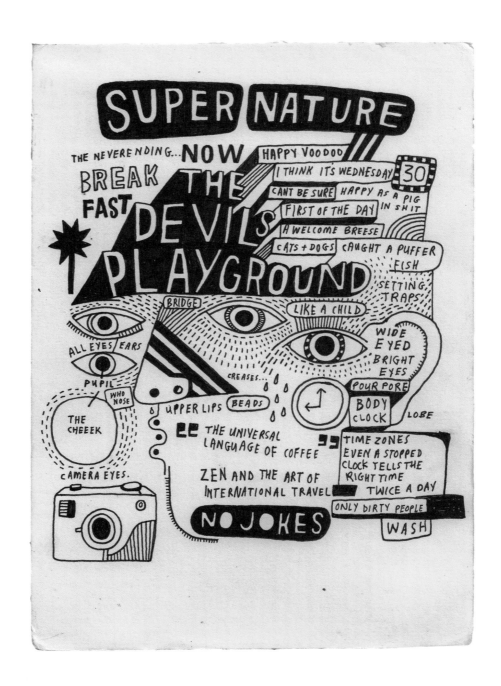

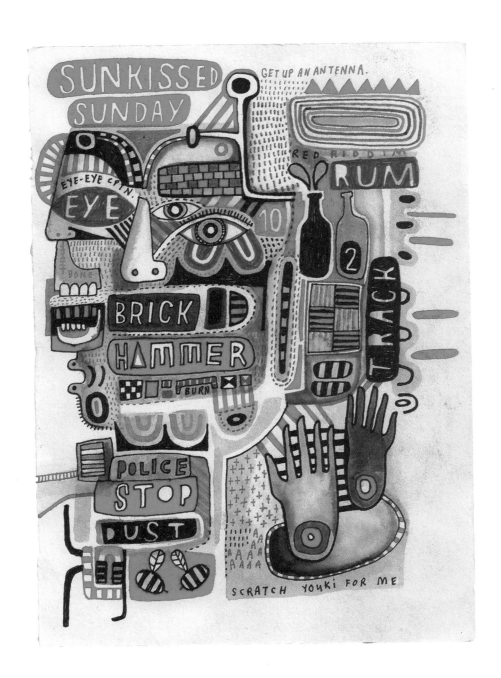

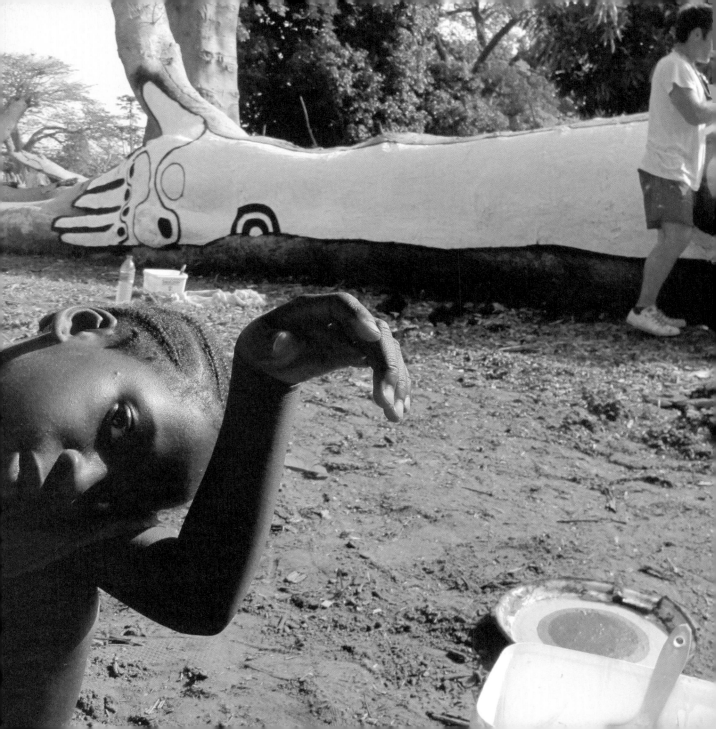

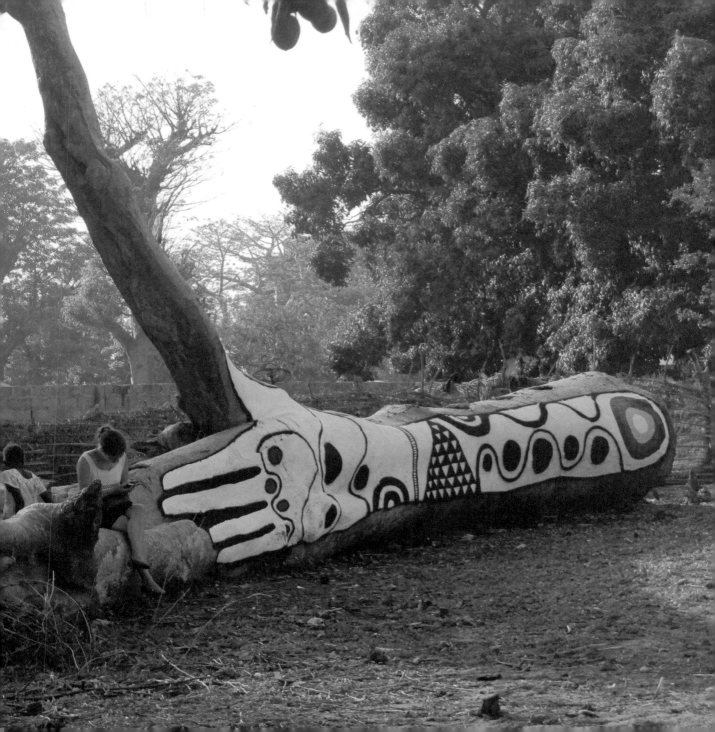

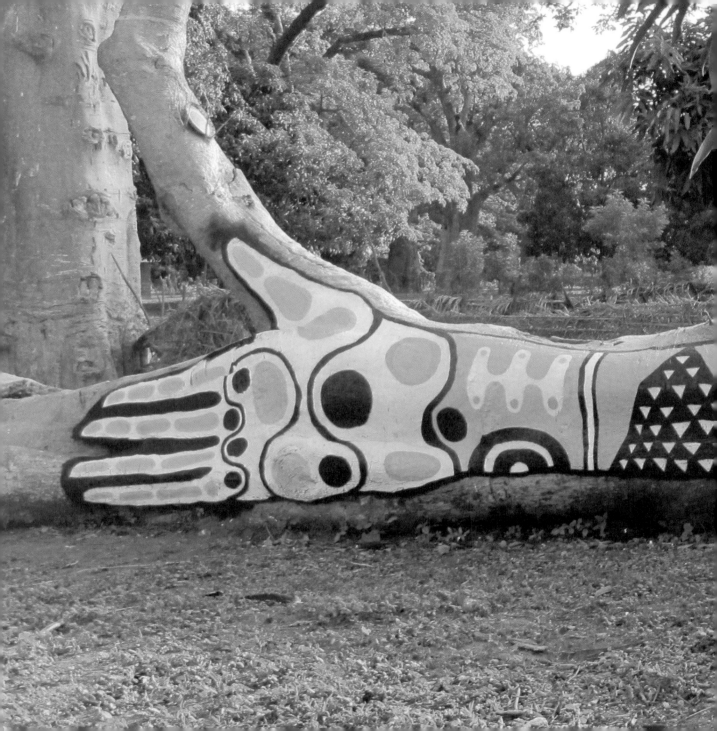

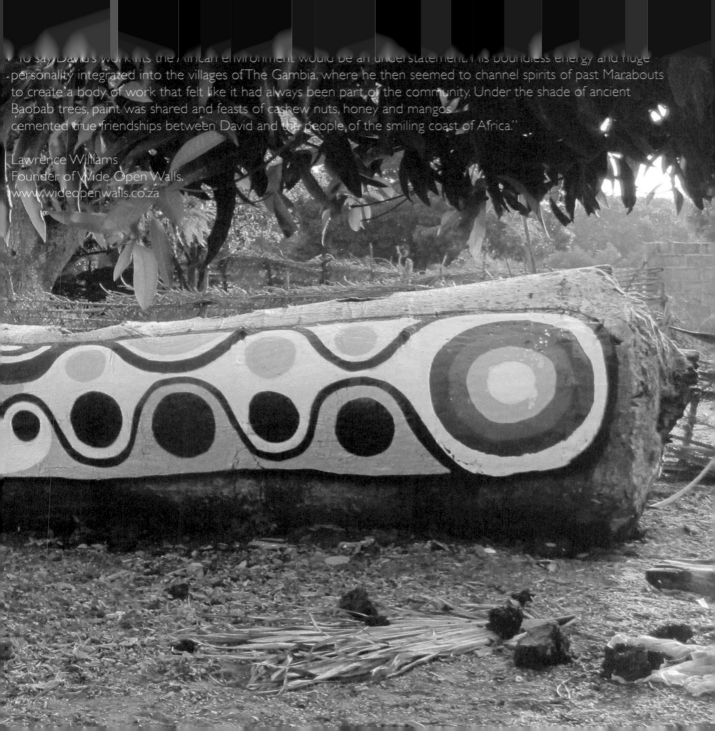

"To say David's work fits the African environment would be an understatement. His boundless energy and huge personality integrated into the villages of The Gambia, where he then seemed to channel spirits of past Marabouts to create a body of work that felt like it had always been part of the community. Under the shade of ancient Baobab trees, paint was shared and feasts of cashew nuts, honey and mangos cemented true friendships between David and the people of the smiling coast of Africa."

Lawrence Williams
Founder of Wide Open Walls.
www.wideopenwalls.co.za

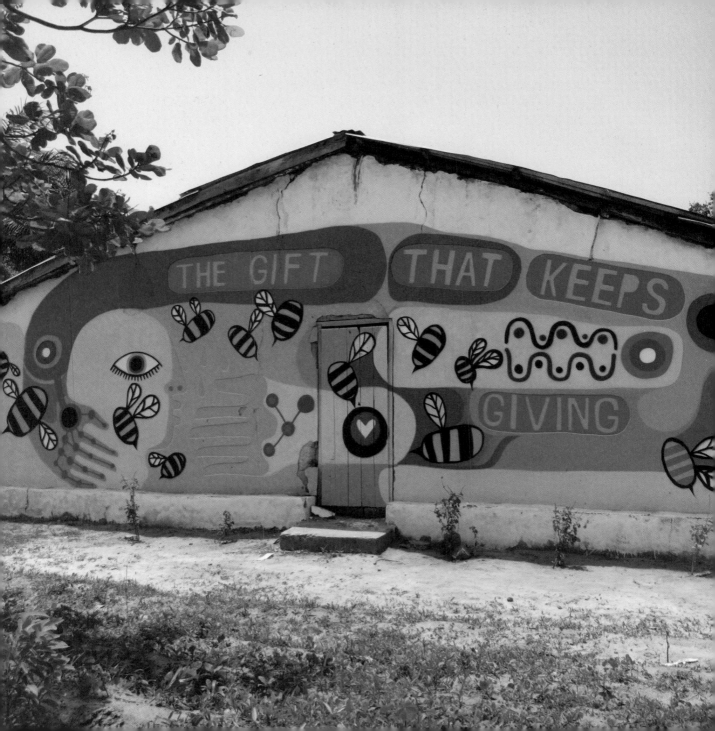

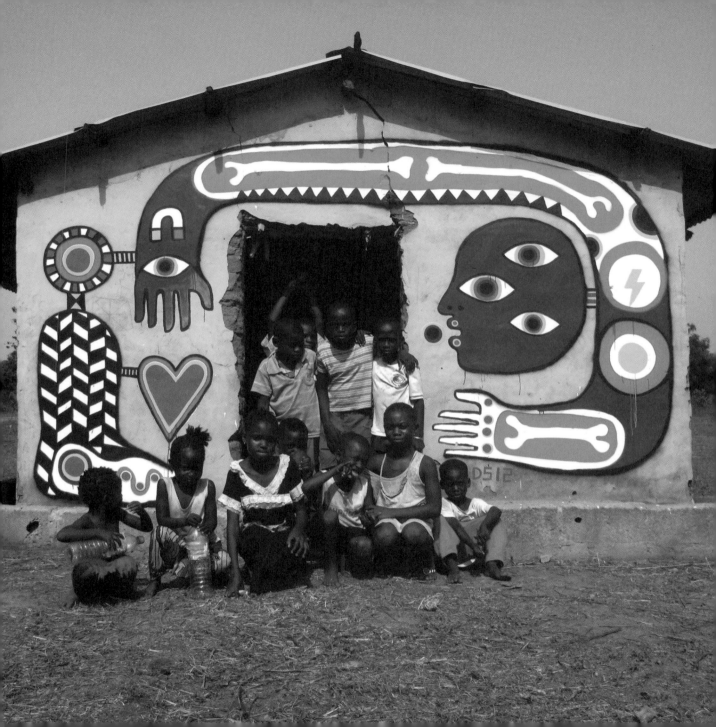

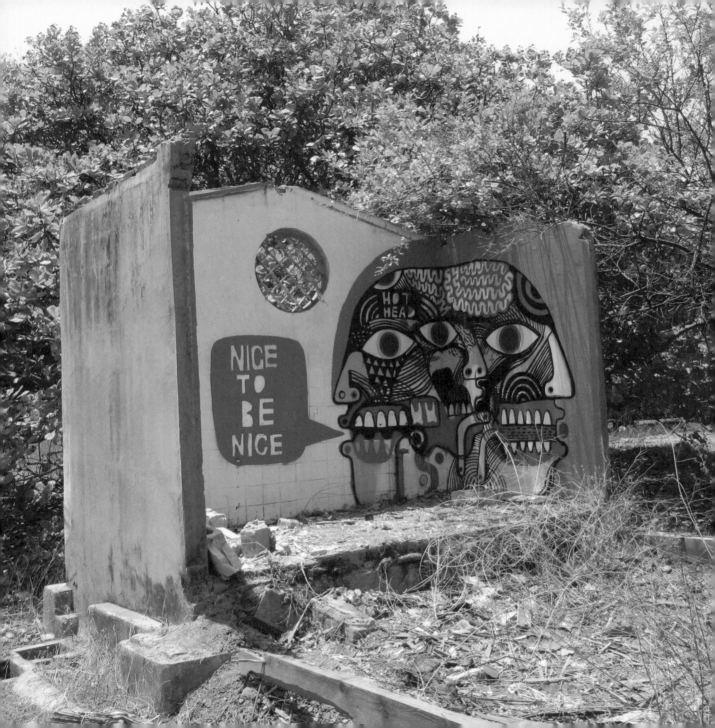

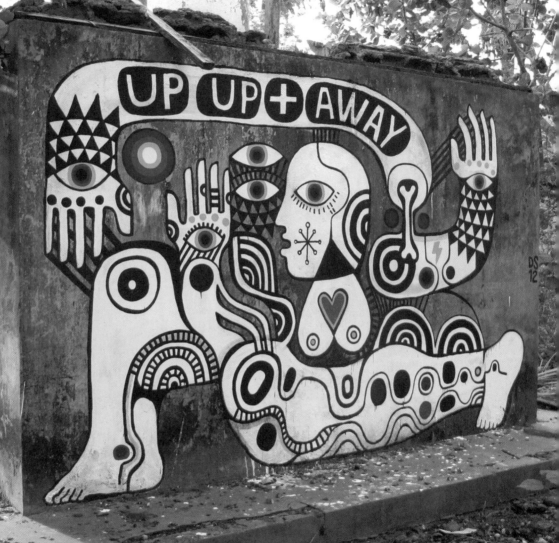

DRAWINGS/ PAINTINGS

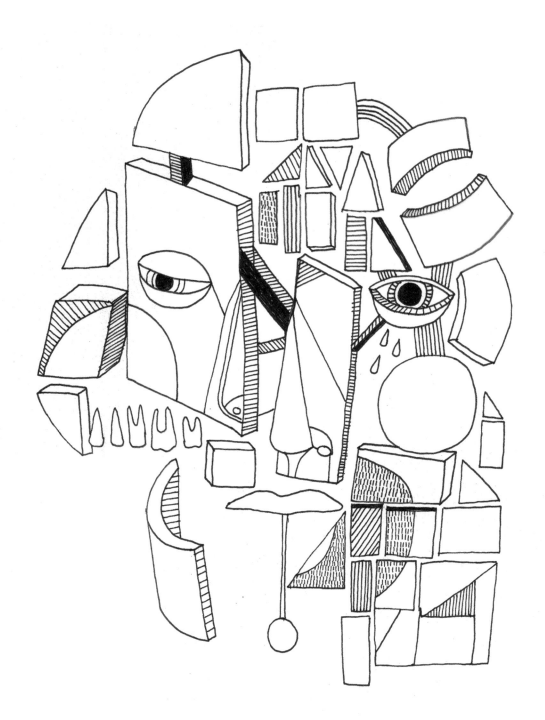

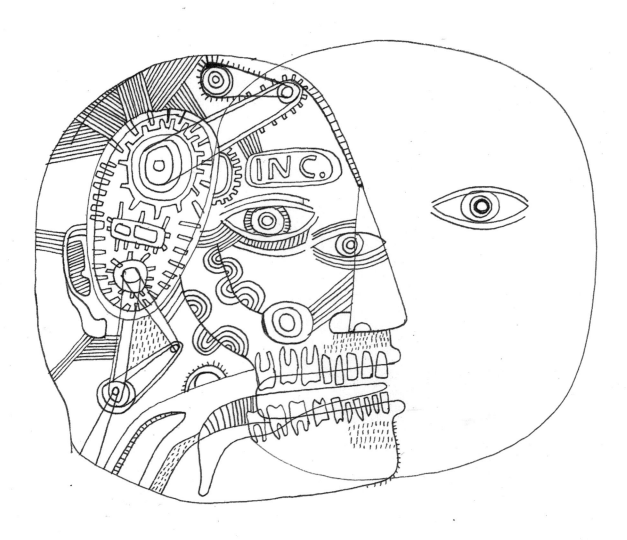

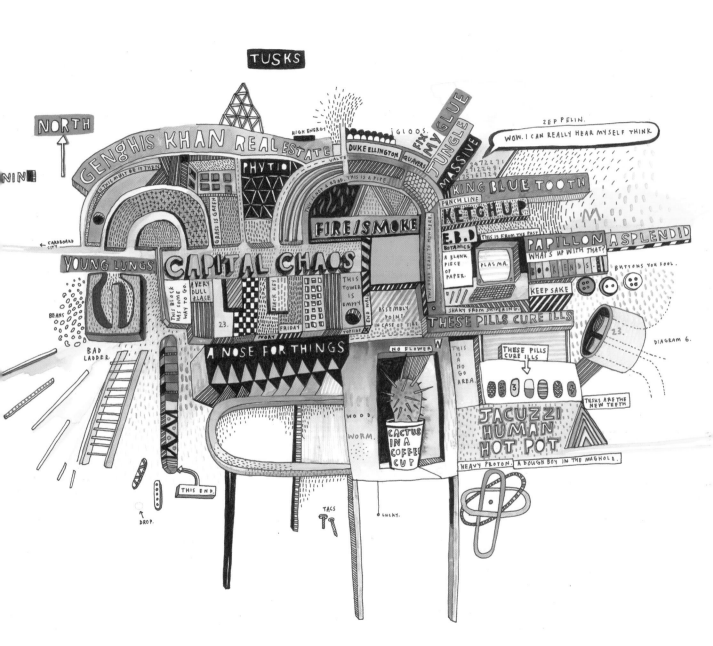

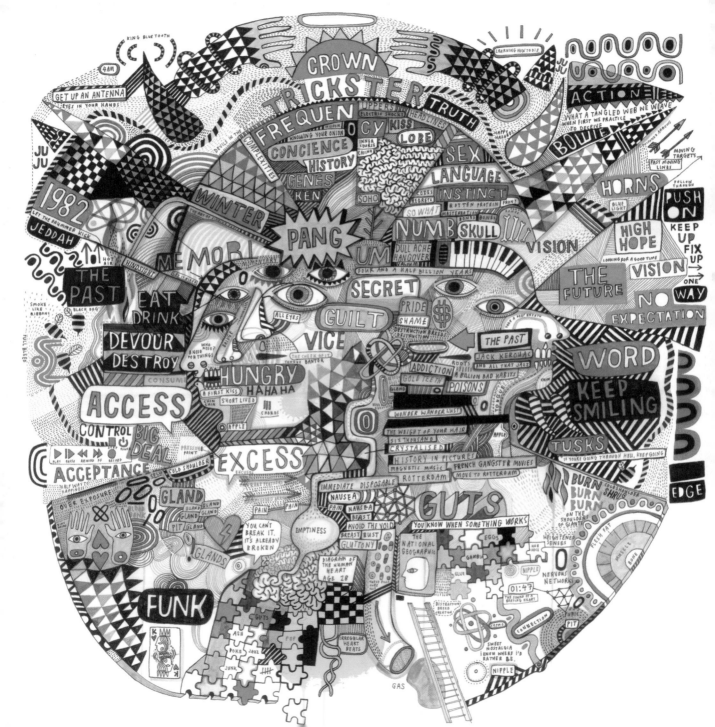

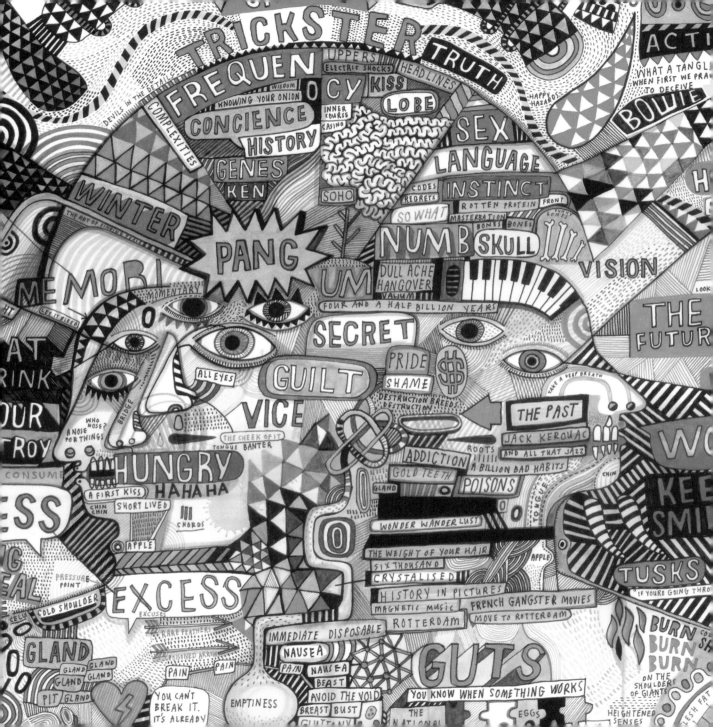

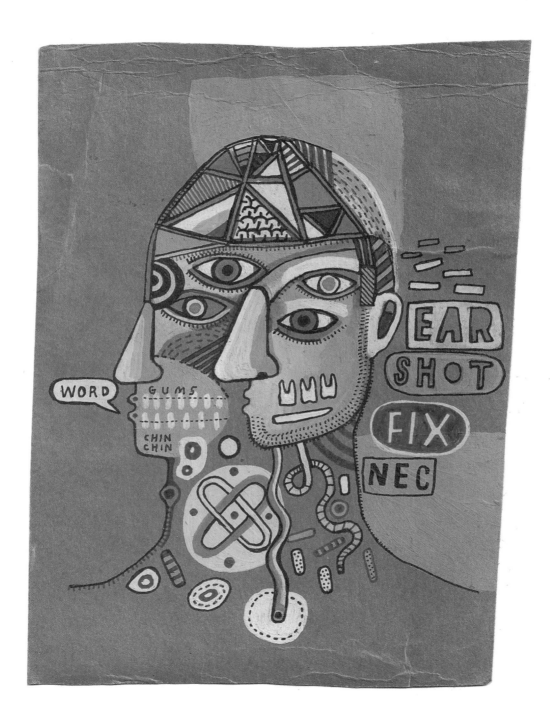

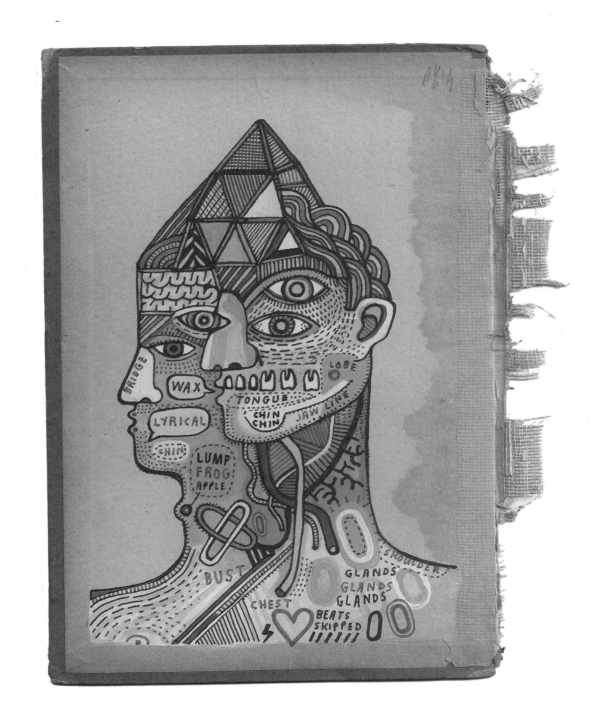

53

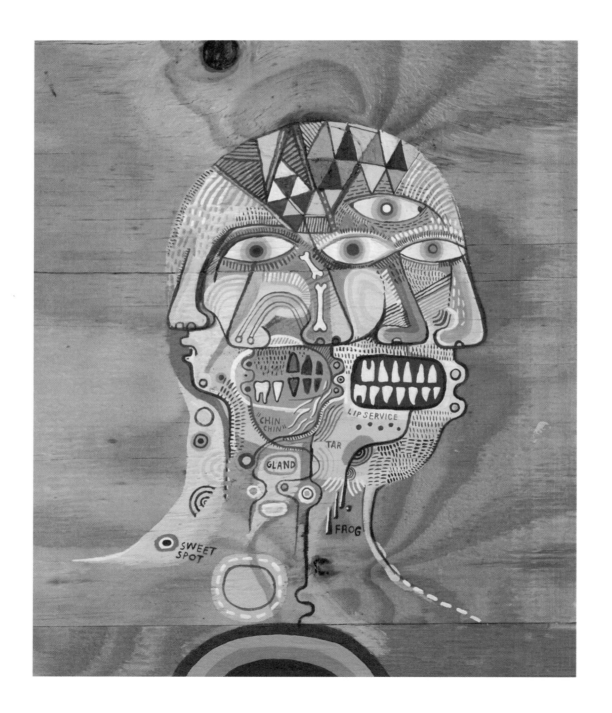

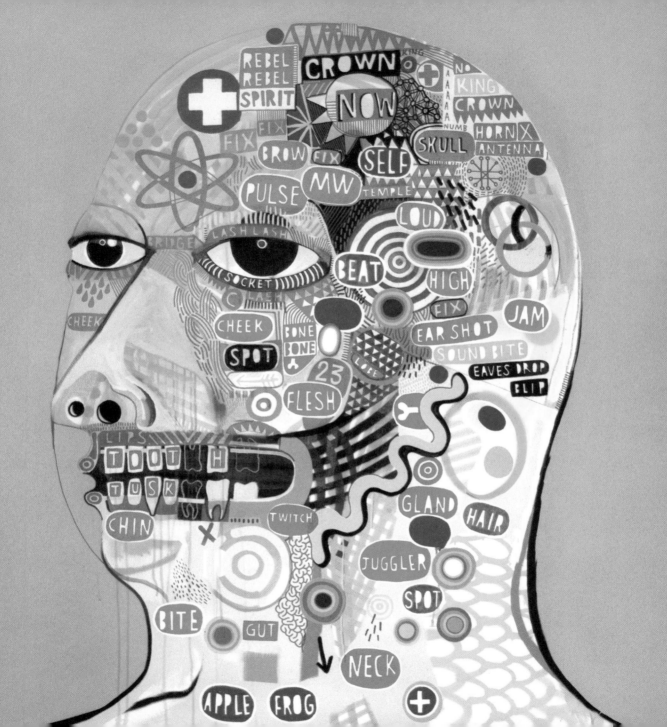

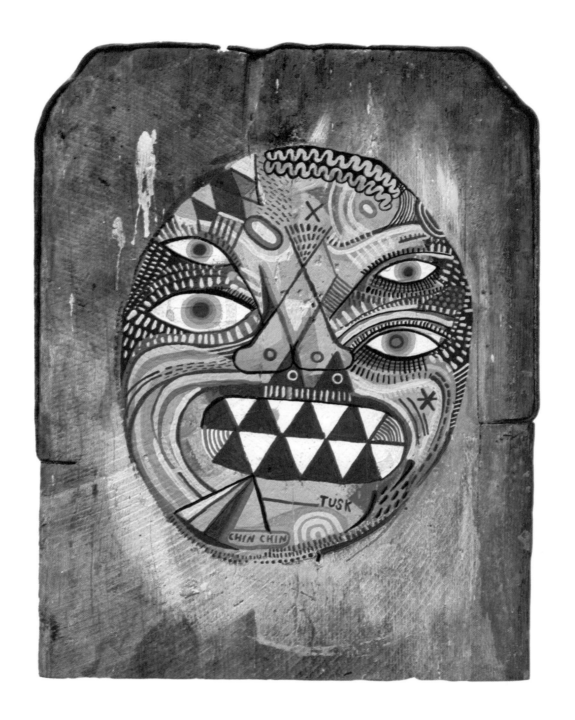

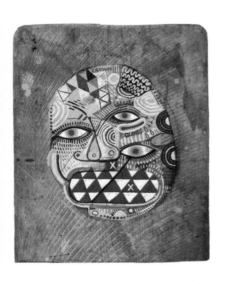
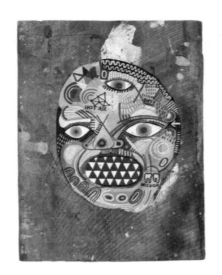
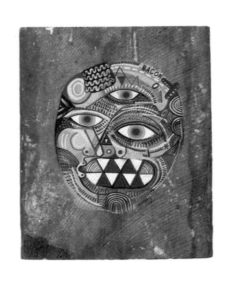
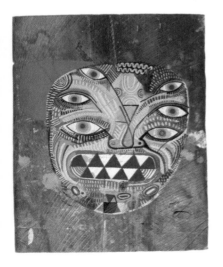
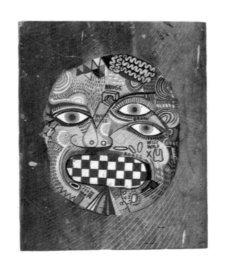
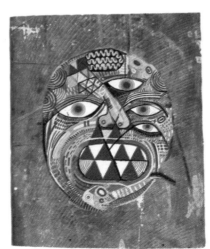

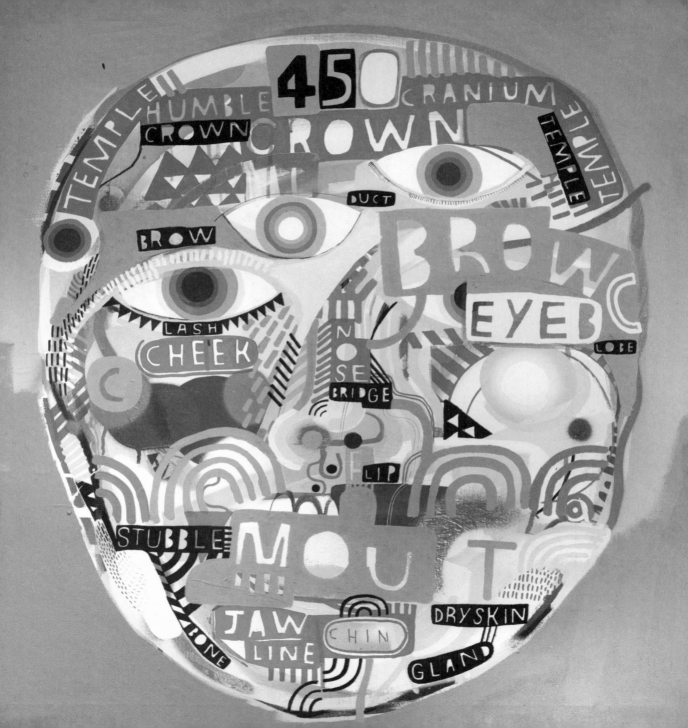

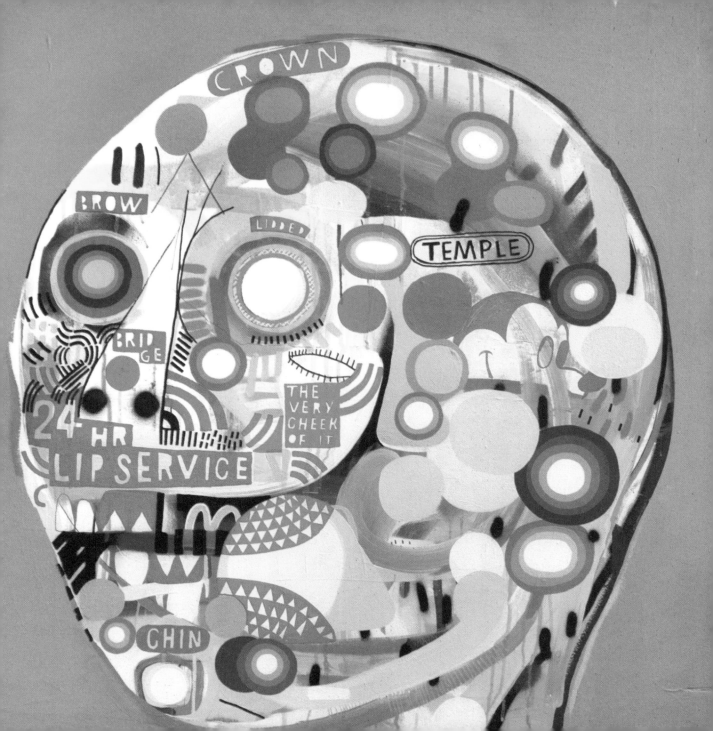

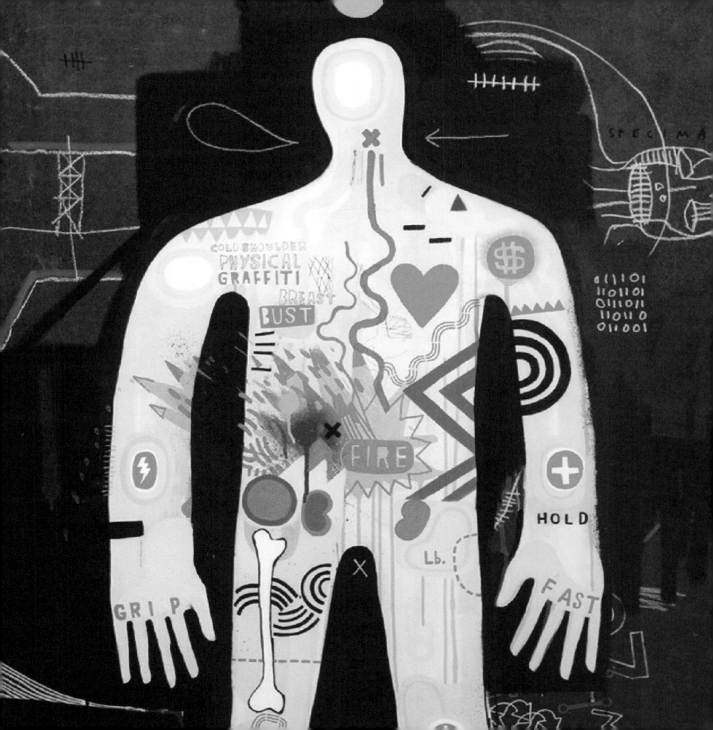

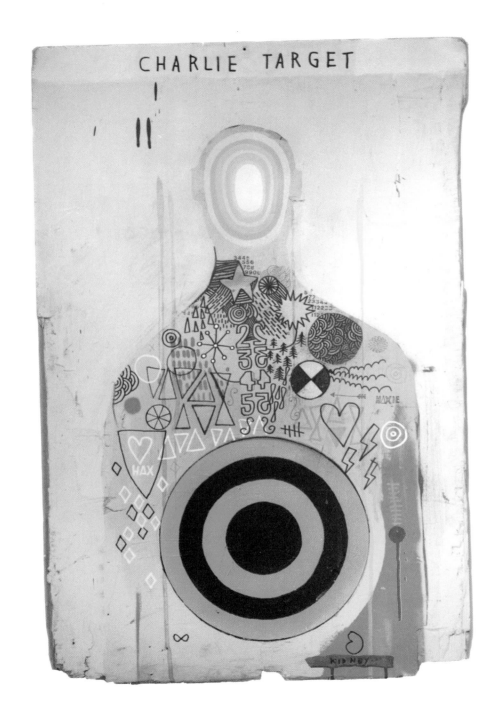

61

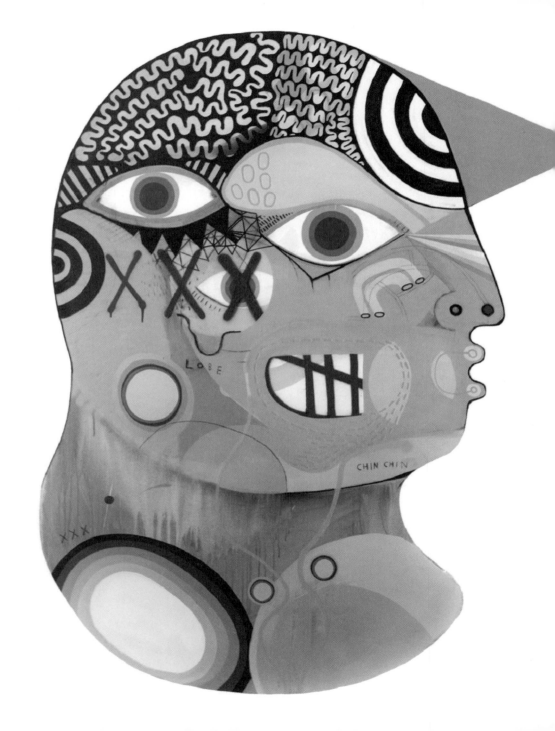

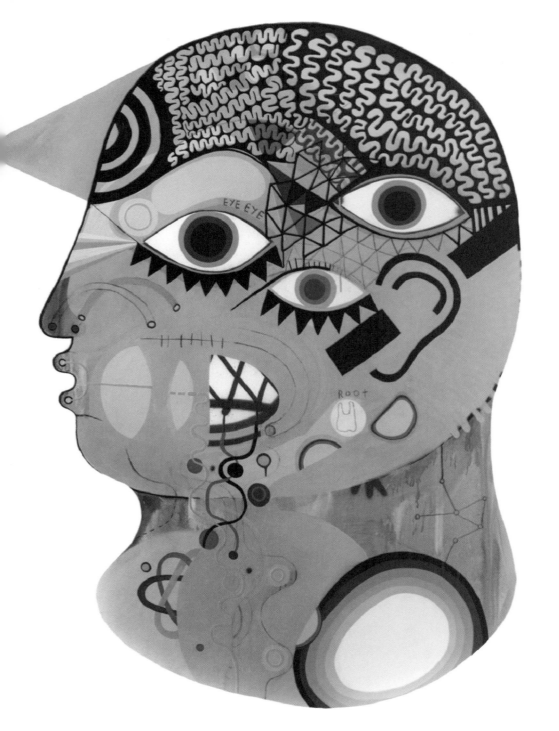

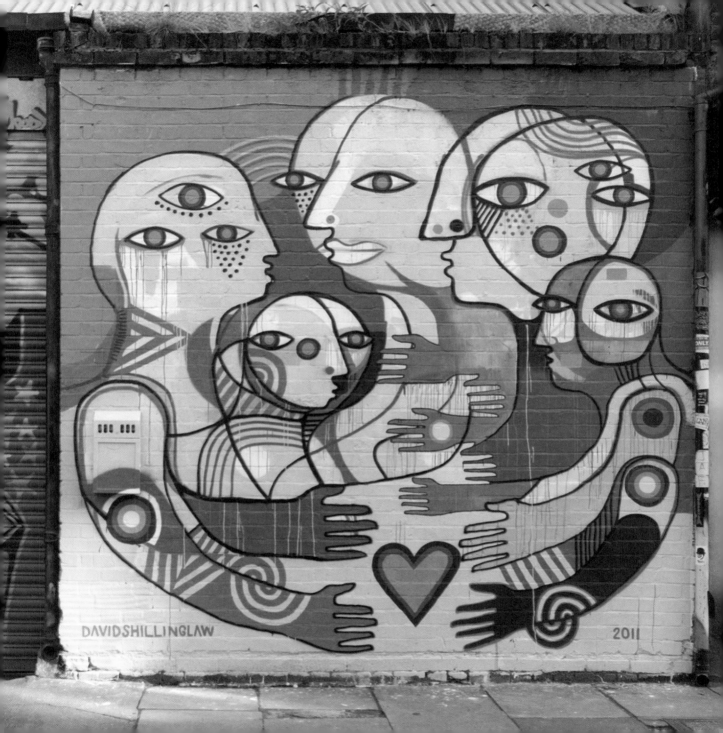

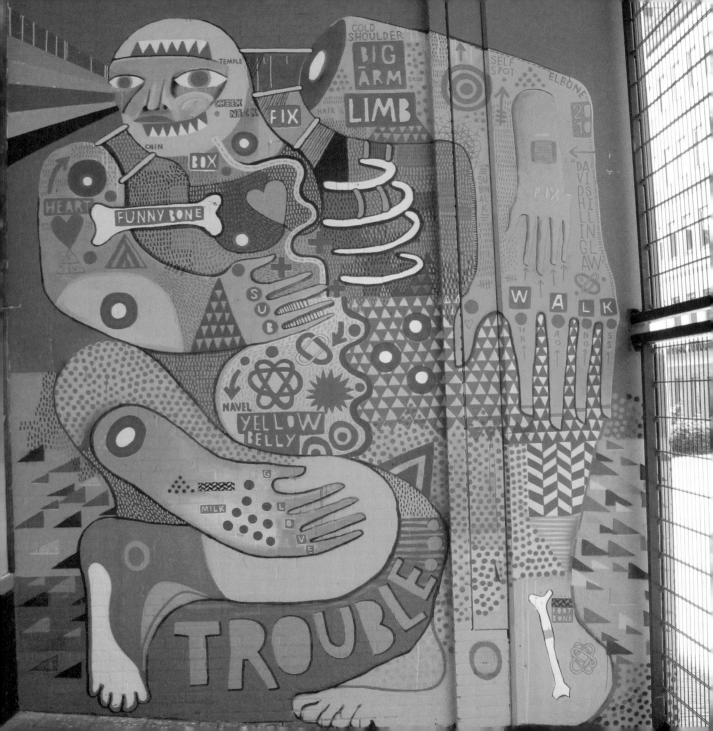

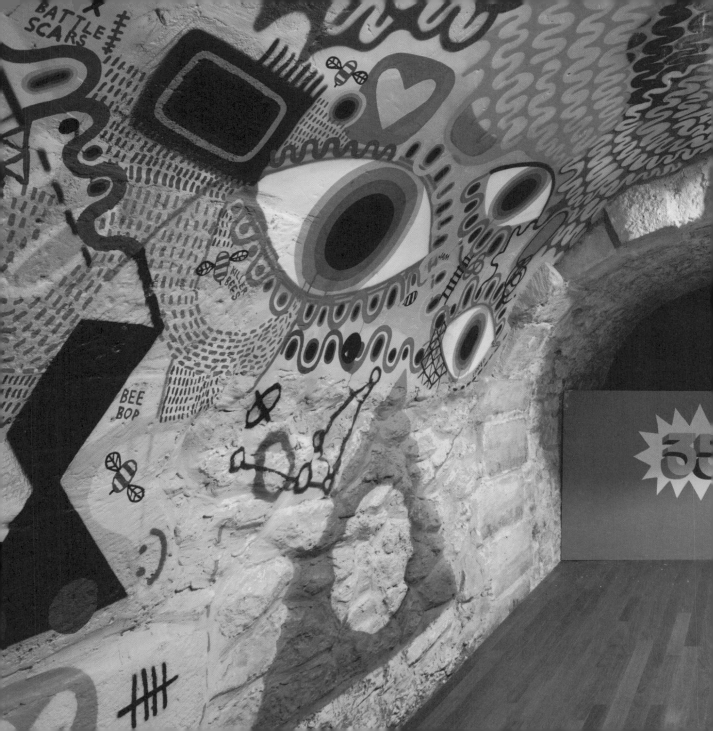

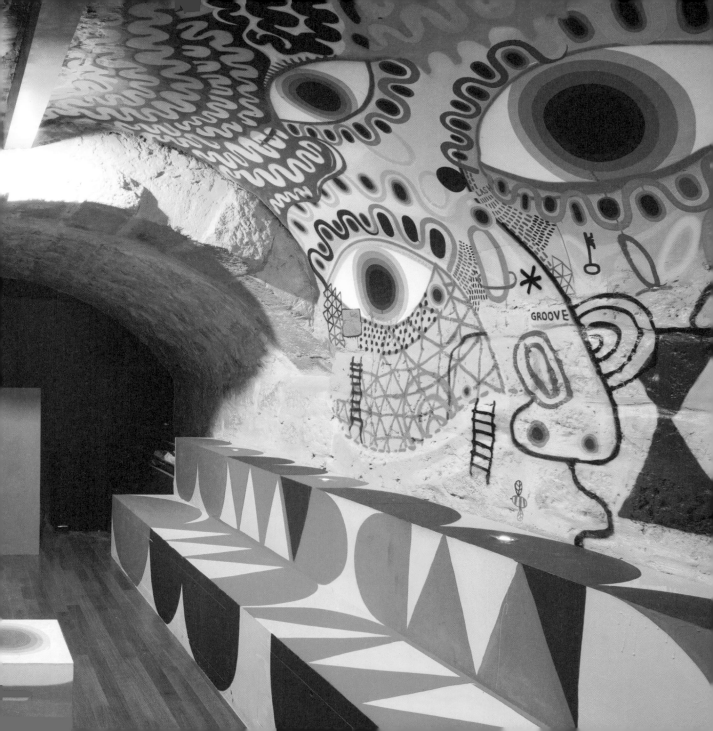

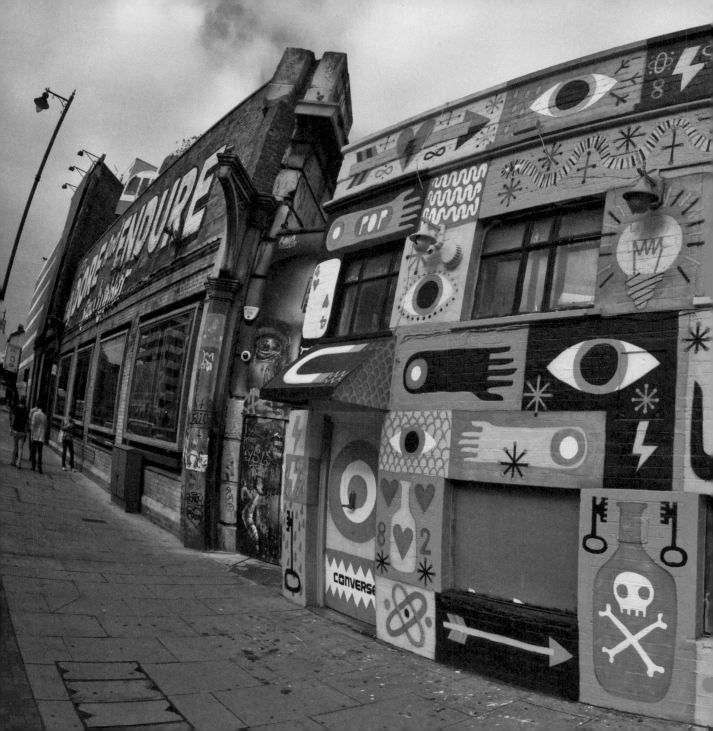

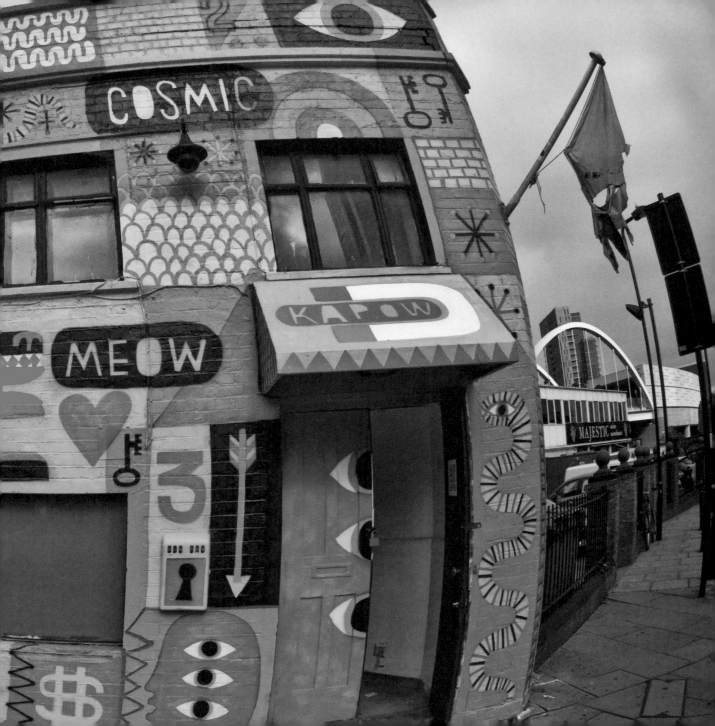

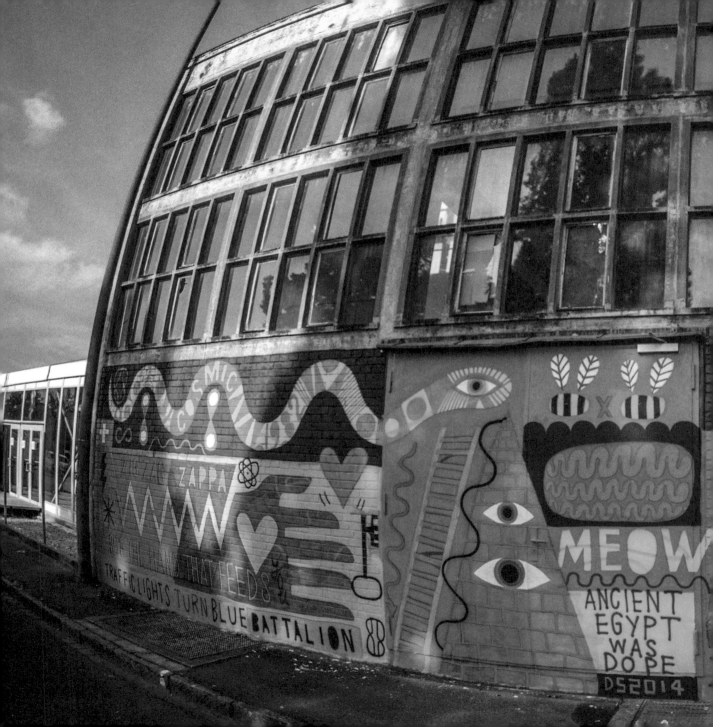

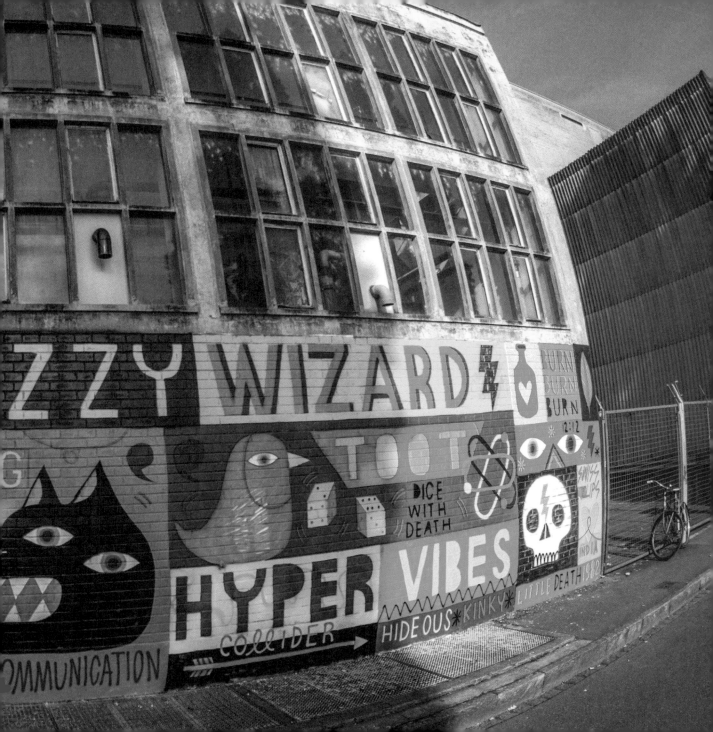

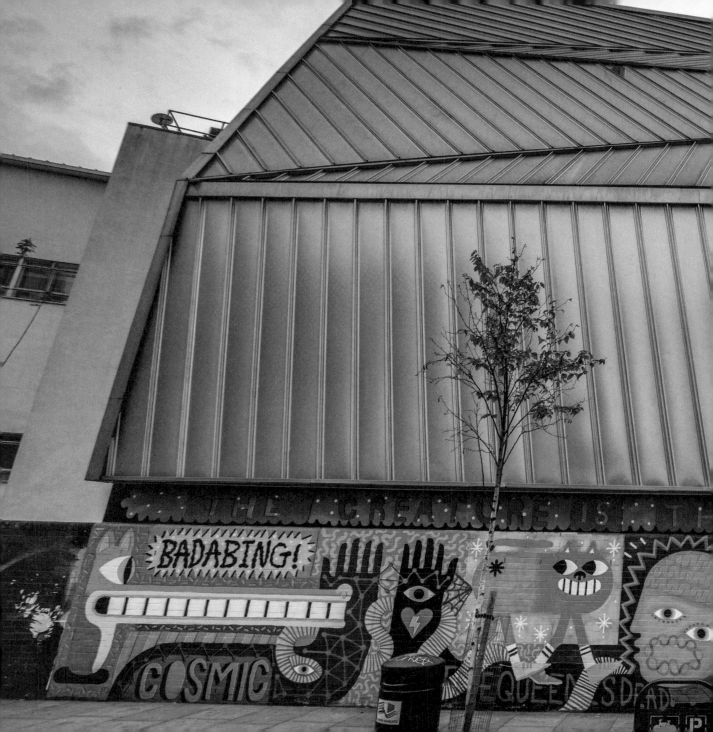

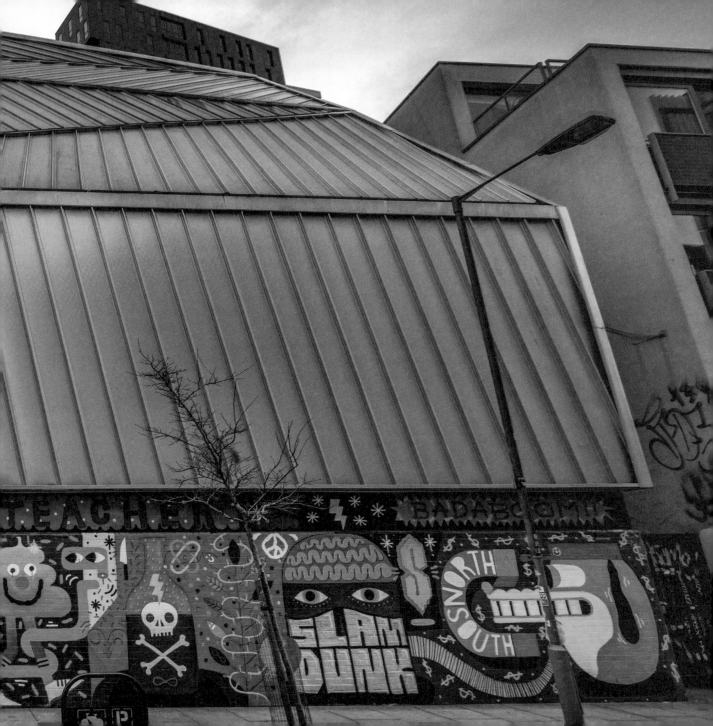

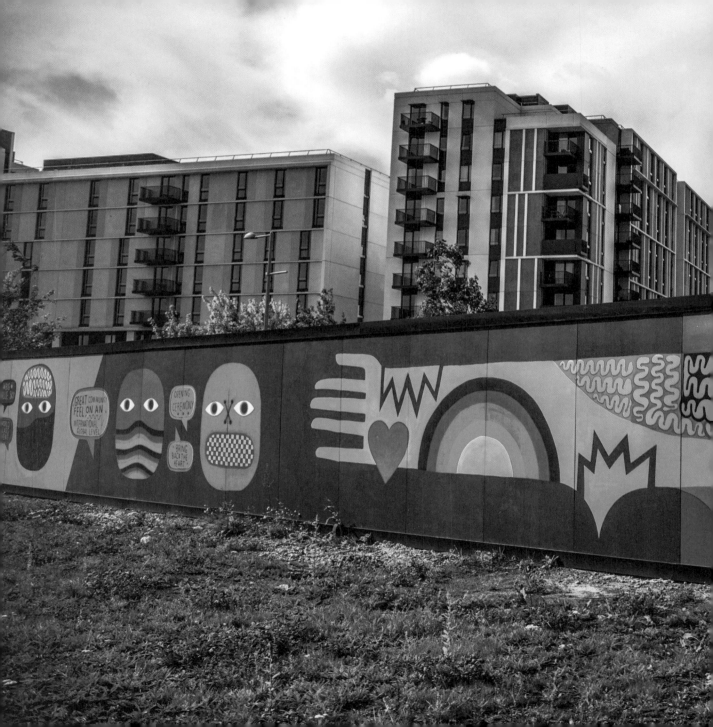

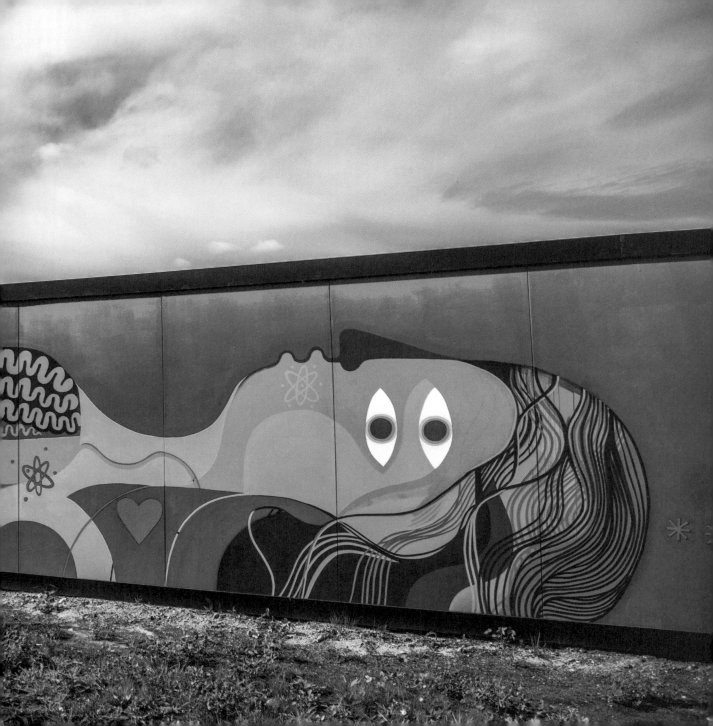

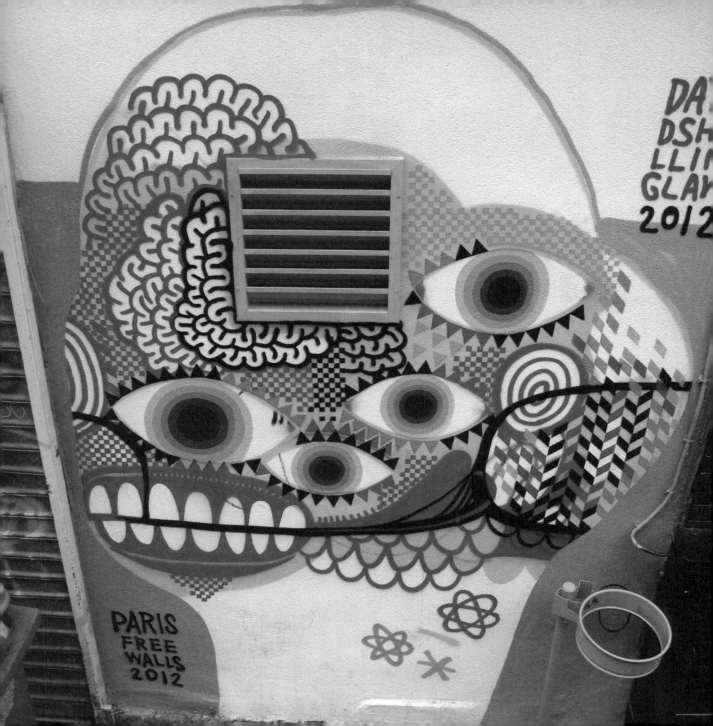

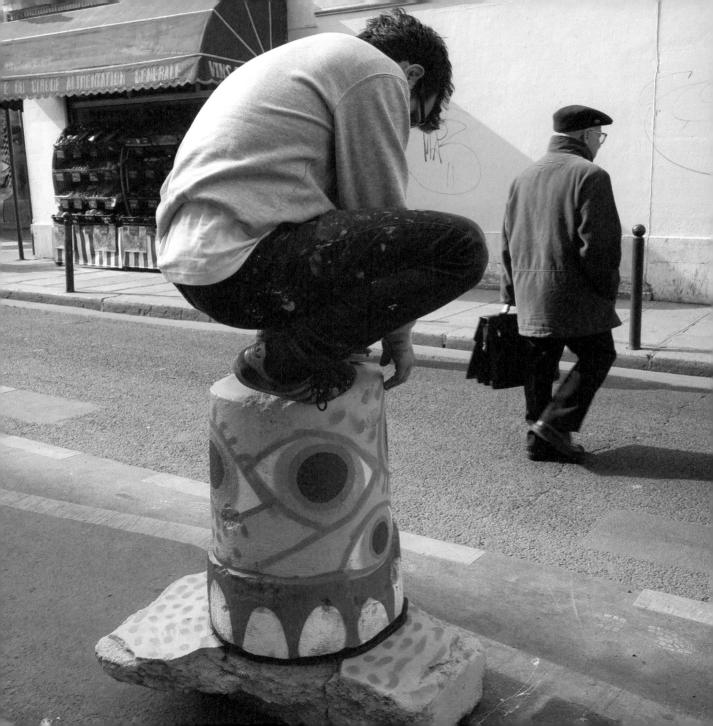

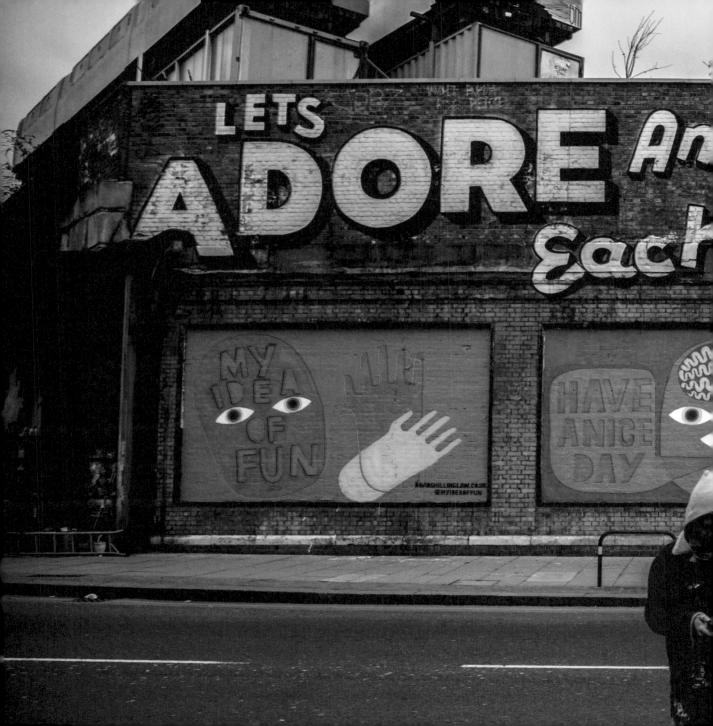

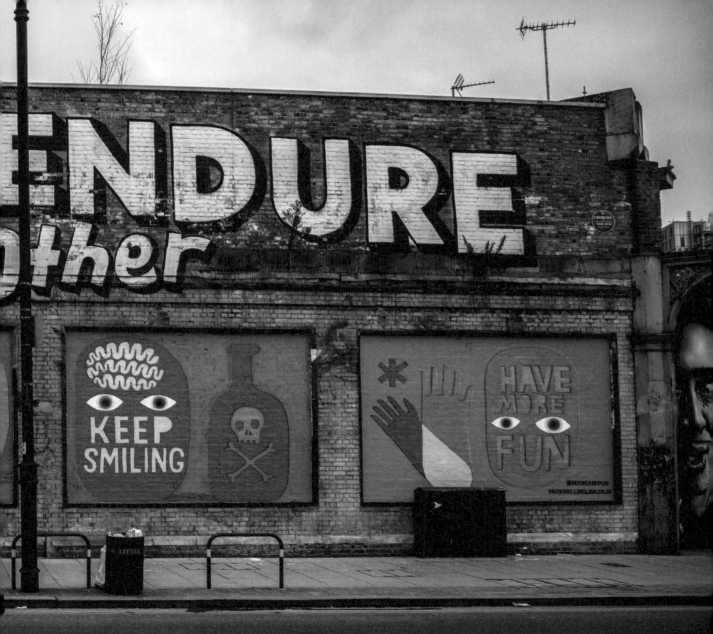

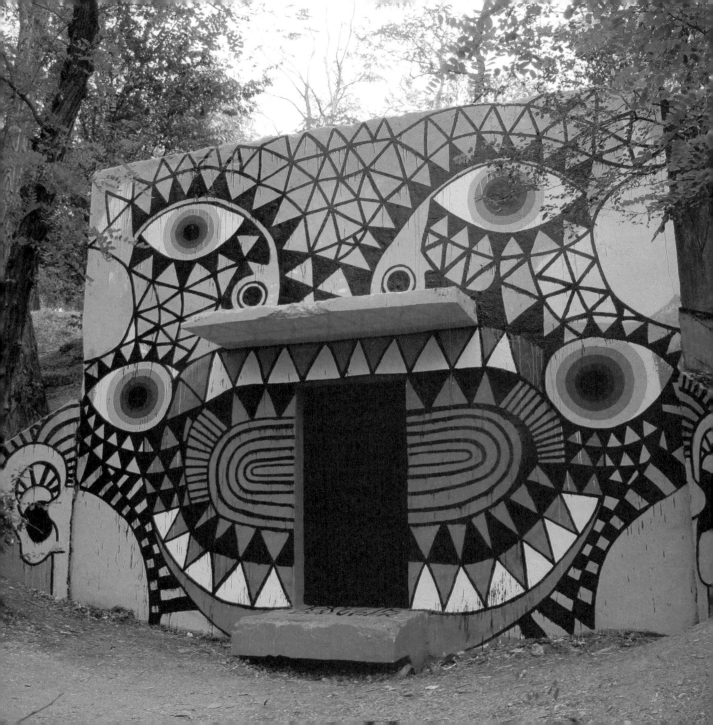

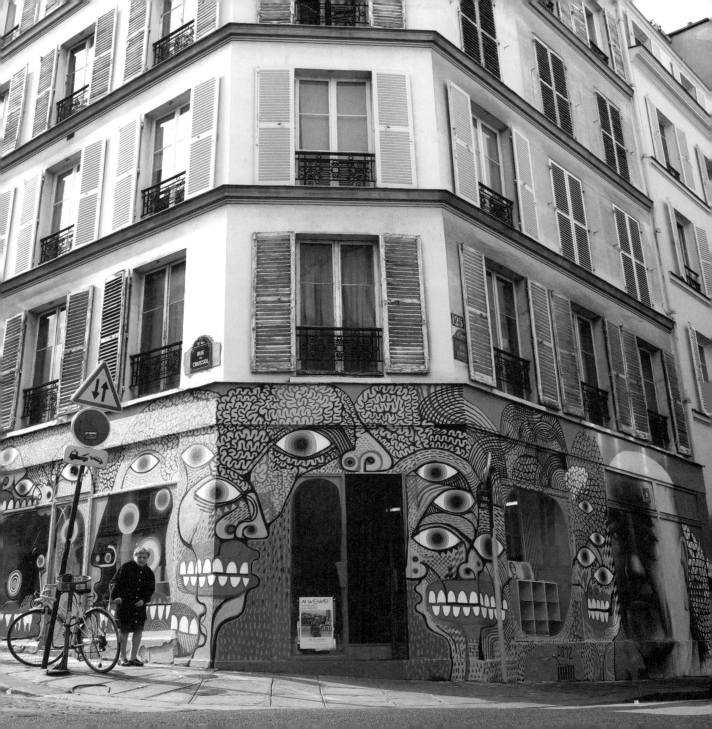

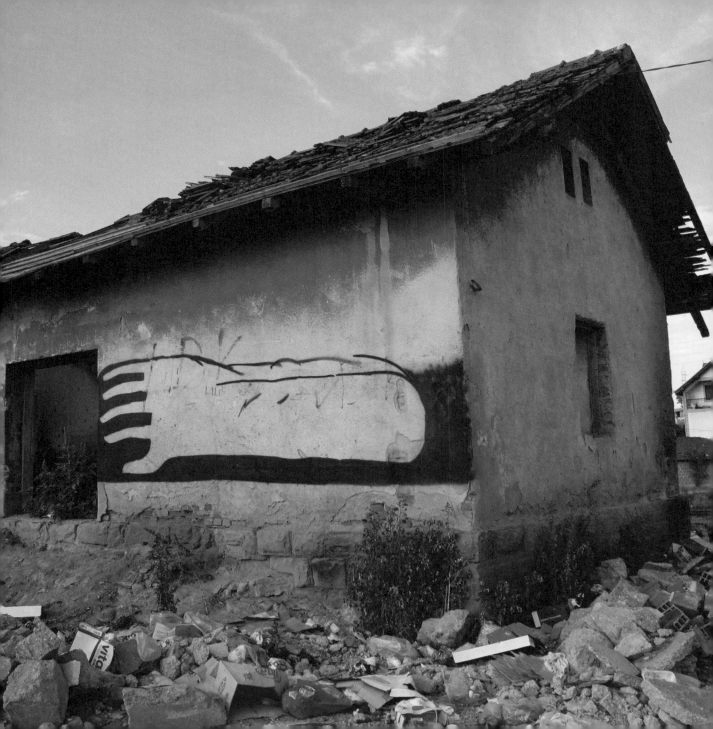

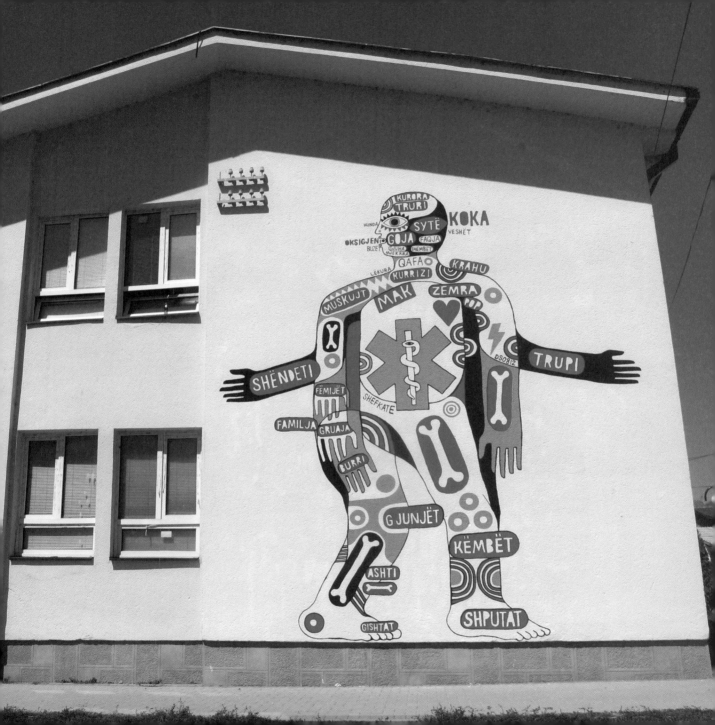

WATER

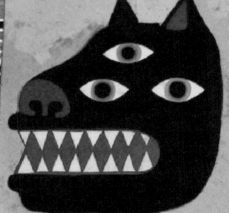

MELON

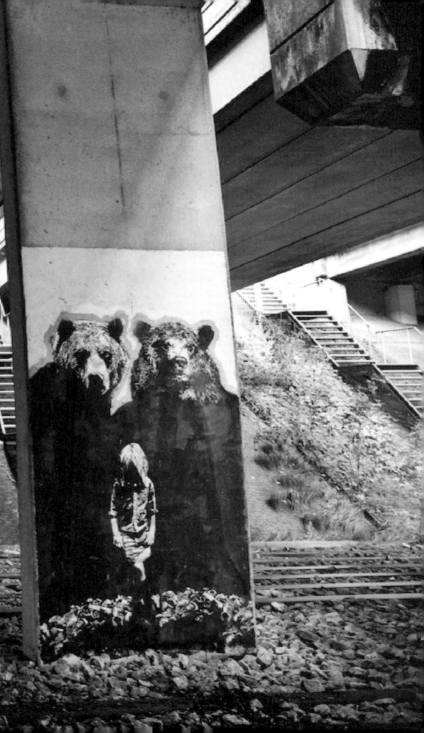
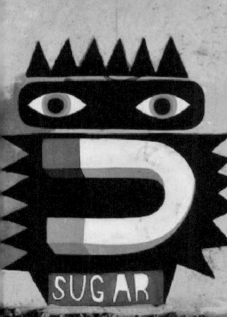

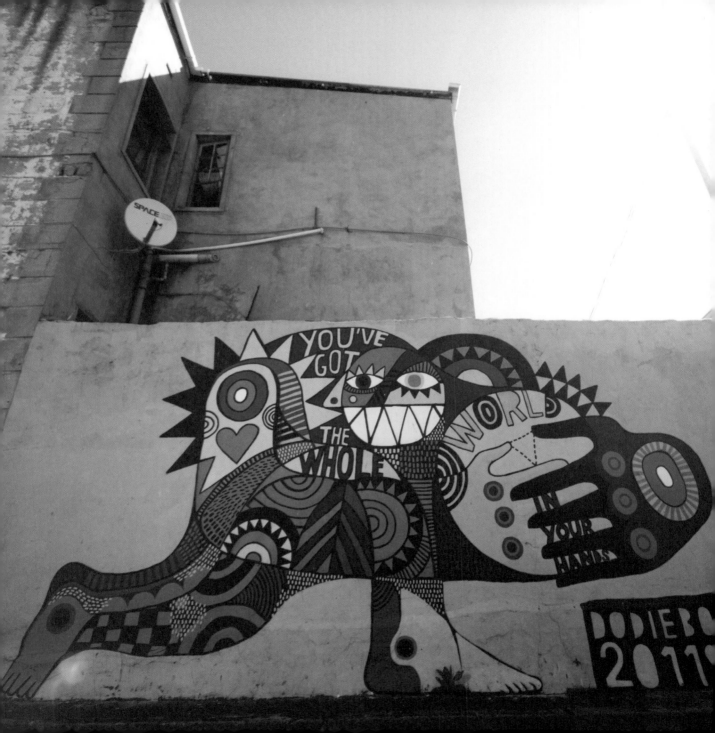

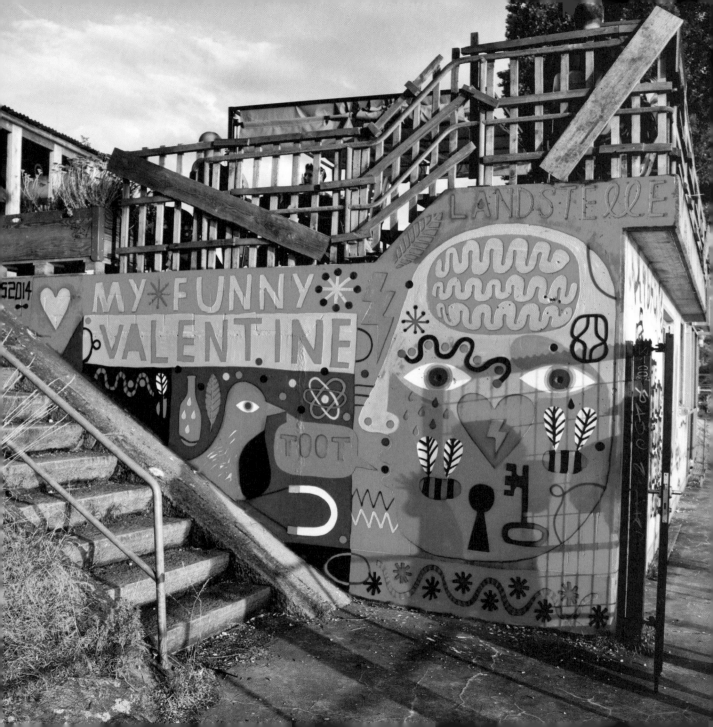

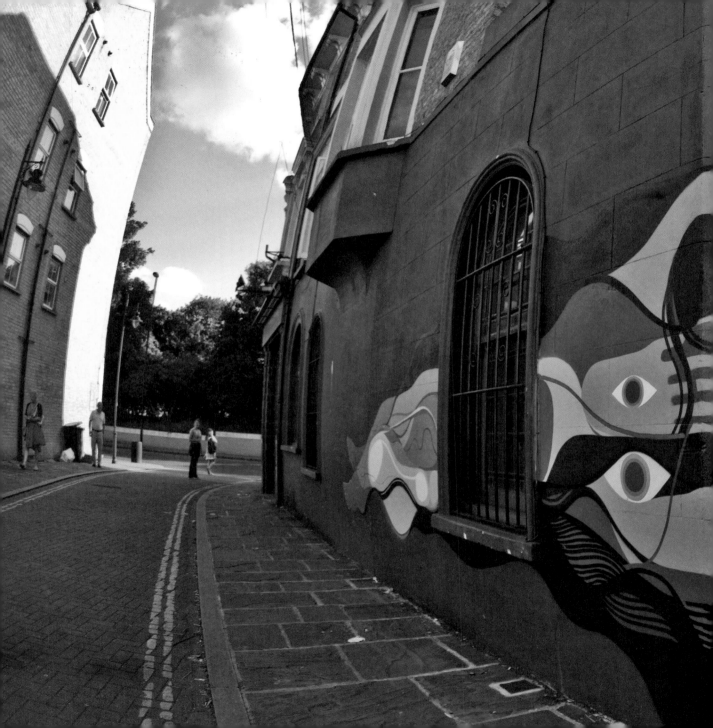

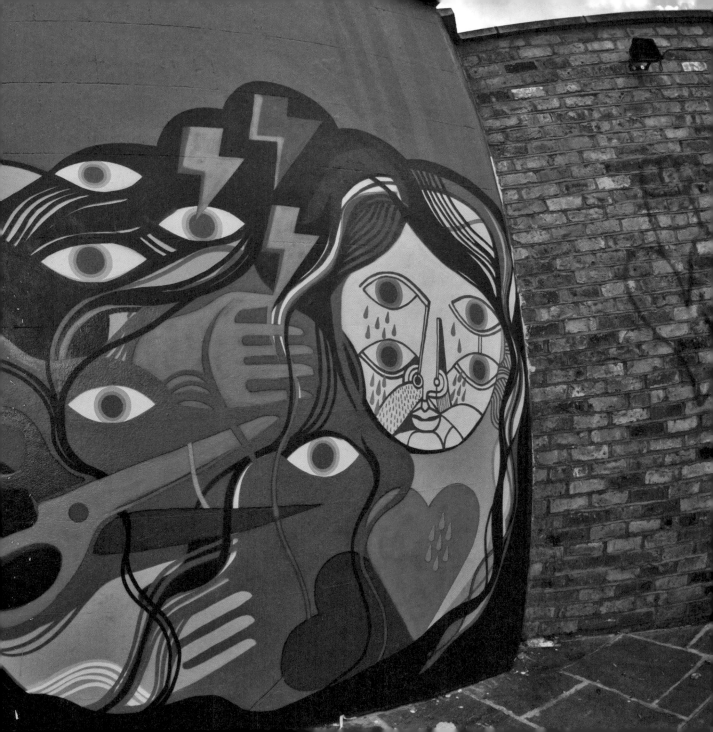

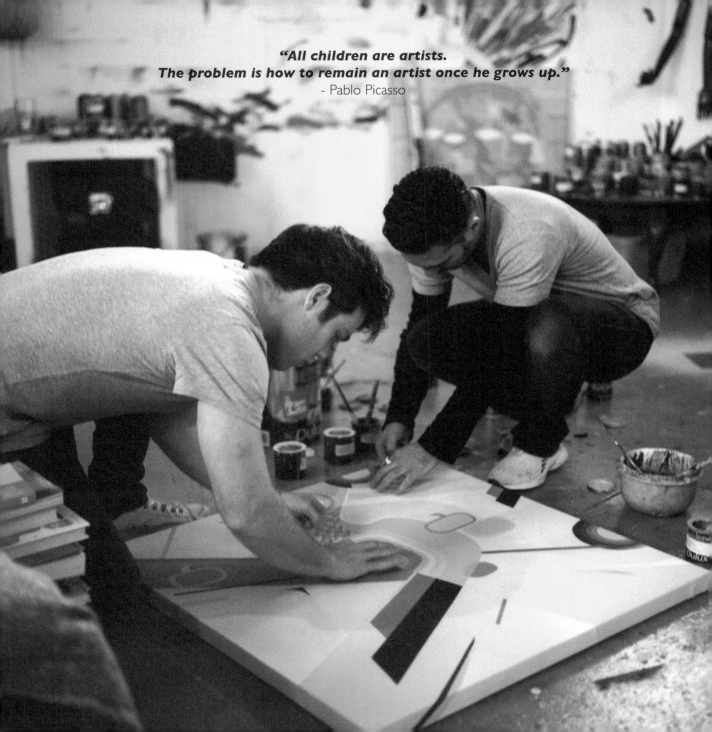

*"All children are artists.
The problem is how to remain an artist once he grows up."*
- Pablo Picasso

This quote is apt for two reasons... The first is that David Shillinglaw's wonderful art has a playful, almost childlike quality even within it's darker subject matters. The second is that David always references Picasso as an influence and motivation.

David Shillinglaw is an artists artist. He is as much at home discussing Kandinsky's theories as he is having a few beers with friends and not discussing art whatsoever. His paintings are narratives of his interest in the world around him. He acquires so many images, words and references on his many travels that sometimes it's hard to even know what nationality he is. Nonetheless he is an ardent worker and makes things more beautiful every day he works.

The way he integrates language into his paintings and drawings says more about his place in the future of art history than most other artists. He says, where most are happy just doing... The word is a mighty weapon and he uses it profoundly. His recent trip to the Gambia cemented his future in my opinion. He made art with the people for the people and came back with a vision to return and do more for the people there.

Not only is David fast becoming a truly 'great' artist but he is a kind and giving human being and I for one am very honoured to call him my friend.

- Remi/Rough

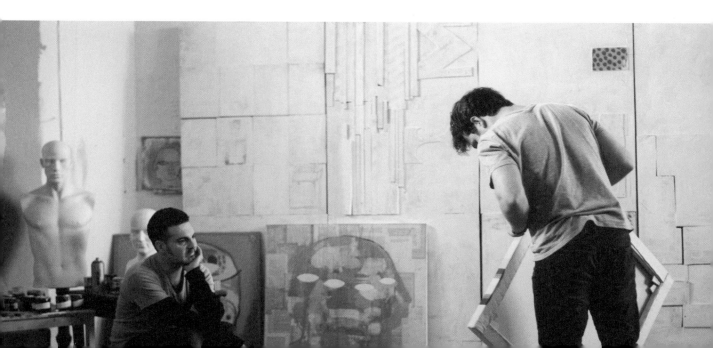

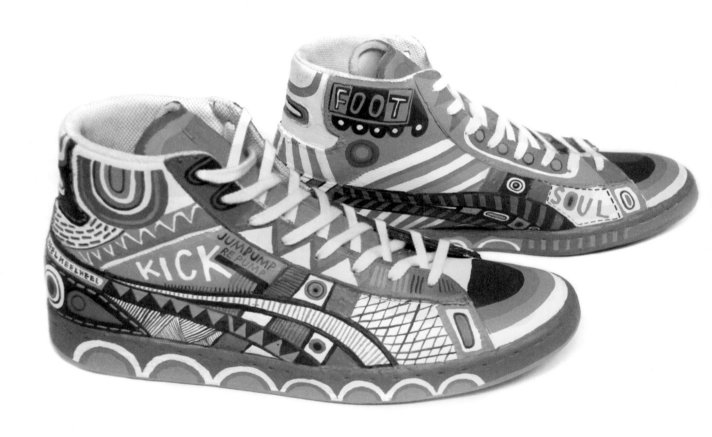

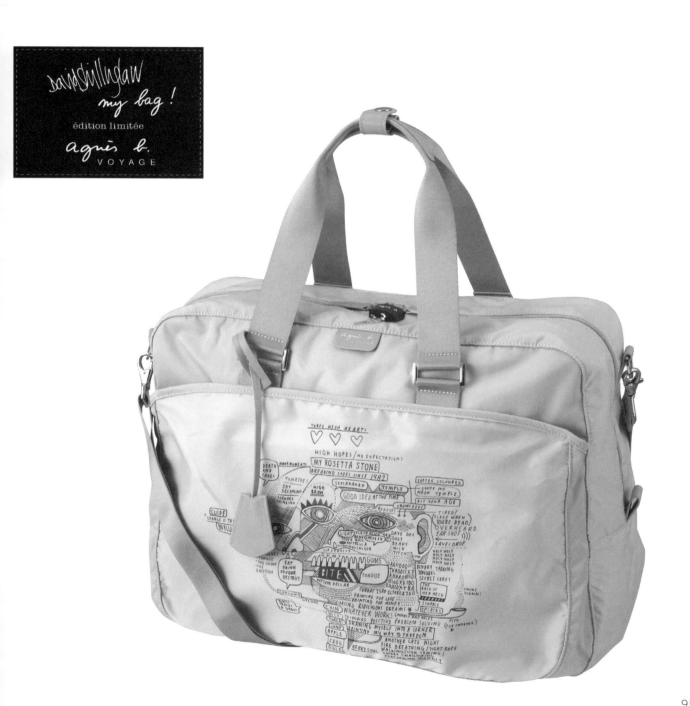

PAGES AND PROPS

Big love and thanks to my friends and family for continual support.
A special thanks to Agnes b for helping to make this book happen.

www.davidshillinglaw.co.uk